IN *the* FULLNESS *of* TIME

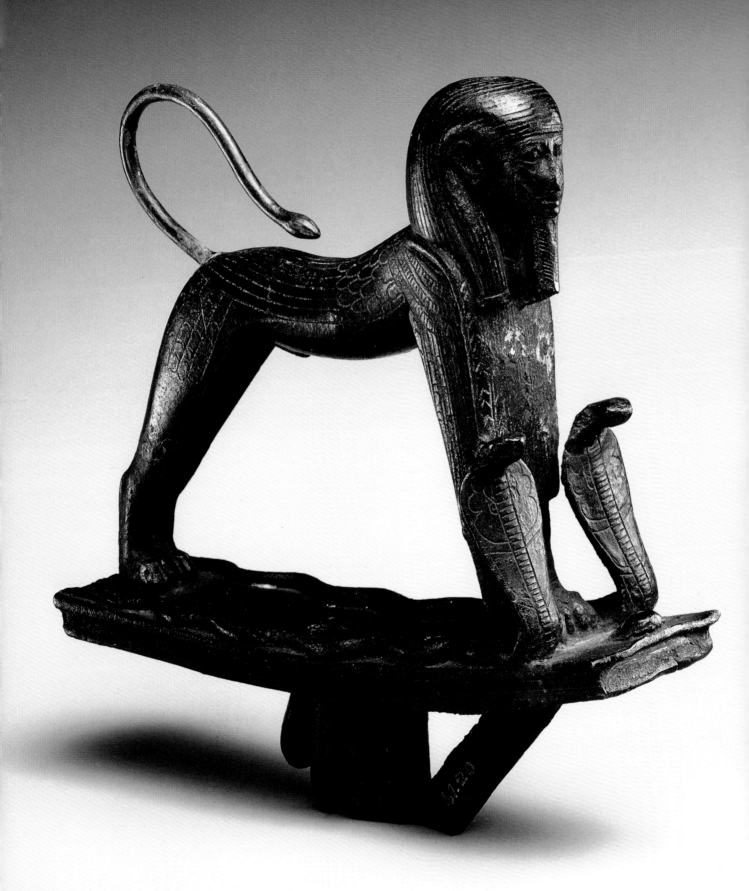

In *the* Fullness *of* Time:

Masterpieces of Egyptian Art
from American Collections

James F. Romano

Introduction by John Olbrantz

Hallie Ford Museum of Art
Willamette University

distributed by
University of Washington Press
Seattle and London

This book was published in connection with the exhibition *In the Fullness of Time: Masterpieces of Egyptian Art from American Collections*, arranged by the Hallie Ford Museum of Art at Willamette University. The dates for the exhibition were August 31, 2002–January 4, 2003. The exhibition traveled to the Boise Art Museum in Idaho, where it was presented March 8–July 29, 2003.

Financial support for the exhibition and book was provided by a major grant from an anonymous donor, with additional support provided by the Wyss Foundation, the Oregon Arts Commission, the National Endowment for the Arts, and the City of Salem (through the City of Salem's Transient Occupancy Tax Funds).

Designed by by Phil Kovacevich/Kovacevich Design

Copyedited by Laura Iwasaki

Printed and bound in Canada

Front cover and Fig. 21, page 34: *Statuette of sacred cat of Bastet*. Provenance not known. Late Period, Dynasty 26, 664–525 B.C. Bronze. 26.3 x 8.3 x 15.2 cm (10$\frac{3}{8}$ x 3$\frac{1}{4}$ x 6 in.). Collection of The Detroit Institute of Arts. Gift of Mrs. Lillian Henkel Haass and Miss Constance Haass. 31.72.

Back cover and Fig. 38, page 48: *Amulet of ba-bird*. Saqqara. Ptolemaic Period, 305–30 B.C. Gold, lapis lazuli, turquoise, steatite. 3.1 x 6.8 x 0.9 cm (1$\frac{1}{4}$ x 2$\frac{5}{8}$ x $\frac{3}{8}$ in.). Collection of the Brooklyn Museum of Art. Charles Edwin Wilbour Fund. 37.804E.

Frontispiece and Fig. 20, page 33: *Sphinx standard*. Provenance not known. New Kingdom, Dynasty 19, c. 1292–1190 B.C. Bronze. 12.8 x 12.3 x 3.7 cm (5$\frac{1}{16}$ x 4$\frac{15}{16}$ x 1$\frac{7}{16}$ in.). Collection of the Brooklyn Museum of Art. Charles Edwin Wilbour Fund. 61.20.

Fig. 73, page 81: Line drawing from Torgny Save-Söderbergh, "On Egyptian Representations of Hippopotamus Hunting as a Religious Motive," *Horae Soederblomianae: Travaux publié par la Société Nathan Söderblom* 3 (1953): 7, fig. 1.

Book copyright © 2002 by the Hallie Ford Museum of Art at Willamette University

Essay copyright © 2002 by James F. Romano

Introduction copyright © 2002 by John Olbrantz

Figs. 4, 6, 51, 53, 58, 60, 62, courtesy, Museum of Fine Arts, Boston. Reproduced with permission. ©2002 Museum of Fine Arts, Boston. All rights reserved.

Library of Congress Control Number 2002107070

ISBN 1-930957-52-1

Distributed by
University of Washington Press
P.O. Box 50096
Seattle, Washington 98145-5096

CONTENTS

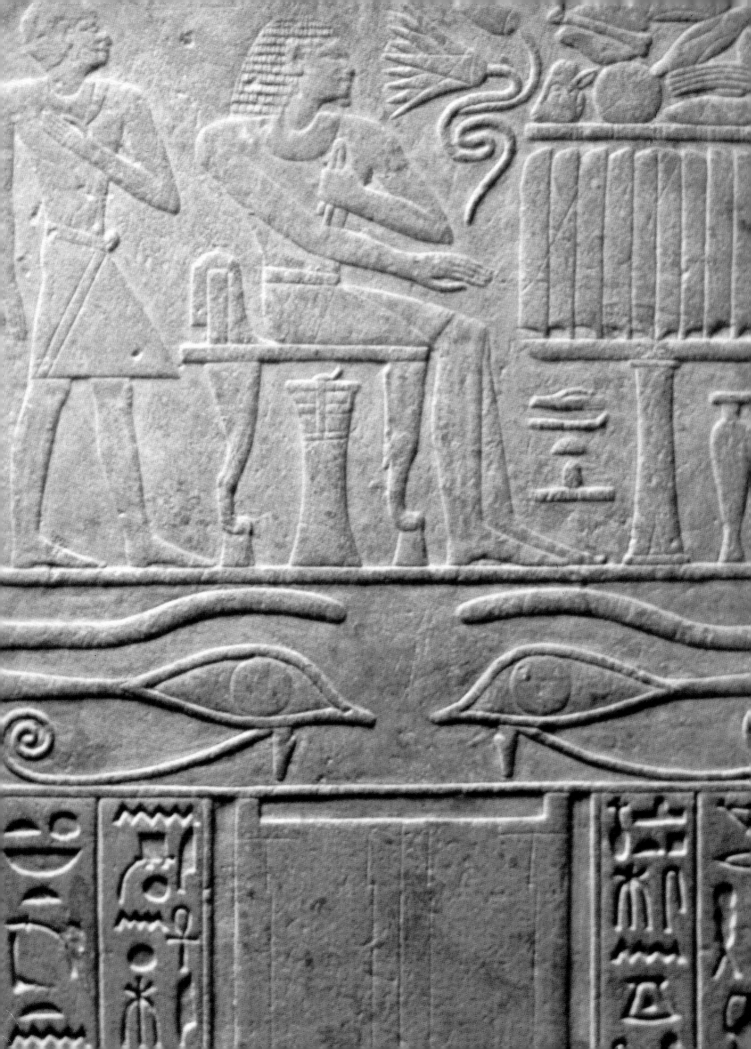

PREFACE

IT MAY HAVE BEEN OVER DINNER at Benjamin's Restaurant in Bellevue, Washington, in the late 1970s or at Yankee Stadium in New York. Maybe it was on a long road trip to Mt. Rainier in the early 1980s or over a 10-cent cup of coffee at Bunk's Drive-In in Bellingham. Who knows: it might have been in my garage in San Jose, California, as we tried to assemble and install a screen door (what the heck is a router?) or at Howard Johnson's in Pittsburgh in 1986. Sometime over the past twenty-five years, Jim Romano and I discussed the possibility of working together on an exhibition of Egyptian art.

Similarly, Sandy Harthorn and I had several conversations about the possibility of sharing an exhibition of Egyptian art over the past few years. Sandy knew of my passion for ancient art, knew that I had organized and/or borrowed a number of exhibitions of ancient art in the past, and knew that I had a number of friends and colleagues who were curators of ancient art around the country. In addition, we had both recently borrowed a wonderful exhibition of Greek and Roman art from the Museum of Fine Arts, Boston, and were eager to share the mystery, magic, and excitement of ancient Egyptian art and culture with our respective audiences.

Fortunately, the idea for an exhibition of Egyptian art moved beyond the idea stage (where, unfortunately, so many great exhibitions linger for years due to a lack of funds) when a donor, who wishes to remain anonymous, agreed to underwrite the cost of the exhibition, publication, and tour. While I initially toyed with the idea of borrowing works from a single institution, I decided early on that we should organize a small, scholarly exhibition of masterpieces of Egyptian art from American collections. The works would be small in scale but of extremely high quality. The exhibition would be problem-based; in other words, each work would be selected because it raised a certain question or problem in Egyptian art history. Finally, the exhibition would be designed to introduce audiences in the West (where very few examples of Egyptian art exist) to important yet rarely seen examples of Egyptian art.

On behalf of the faculty, staff, and students at Willamette University and myself, I would like to express my thanks and appreciation to a number of individuals without whose help this project would not have been possible. I would like to thank my friend and colleague Jim Romano, for agreeing to serve as a consultant to the exhibition, for recommending key examples of Egyptian art that would support the themes of the exhibition, for agreeing to write an extensive essay for the accompanying book, and for his friendship and support over the past twenty-five years. And besides, who else but Jim Romano could incorporate the Grateful Dead, Princess Diana, the "Fonz," and Cookie Monster into a serious, scholarly essay on Egyptian art!

In the Fullness of Time: Masterpieces of Egyptian Art from American Collections would not have been possible without the support of a number of institutions and individuals around the country. In particular, I would like to thank Richard Fazzini, Jim Romano, and Dottie Canady at the Brooklyn Museum of Art; Dave Watters and Deborah Harding at the Carnegie Museum of Natural History, Pittsburgh; Ken Bohač and Gretchen Shie at the Cleveland Museum of Art; Bill Peck and Michelle Peplin at the Detroit Institute of Arts; Dorothea Arnold,

(Fig. 22) Detail, *Stela of Ankhi and Neferhotep.* Provenance not known. Middle Kingdom, Dynasty 12, c. 1938–1759 B.C. Limestone, painted. 60 x 43 x 10.2 cm (23⅝ x 17 x 4⅛ in.). Collection of the Phoebe Apperson Hearst Museum of Anthropology, University of California, Berkeley. 5-352.

Diana Craig Patch, and Nestor Montilla at the Metropolitan Museum of Art; Rita Freed, Larry Berman, and Kim Pashko at the Museum of Fine Arts, Boston; Candy Keller, Carol Redmount, and Joan Knudsen at the Phoebe Apperson Hearst Museum of Anthropology at the University of California, Berkeley; Sid Goldstein and Angie Carter at the Saint Louis Art Museum; David Silverman, Bethany Engel, and Juana Dahlan at the University of Pennsylvania Museum of Archaeology and Anthropology, Philadelphia; and Regine Schulz and Laura Graziano at the Walters Art Museum, Baltimore.

A number of photo archivists and researchers helped gather together photographs and color transparencies for the book. In particular, I would like to thank Ruth Janson at the Brooklyn Museum of Art; Deborah Harding at the Carnegie Museum of Natural History, Pittsburgh; Mary Lineberger and Monica Wolf at the Cleveland Museum of Art; Sylvia Inwood at the Detroit Institute of Arts; Deanna Cross and Rebecca Akan at the Metropolitan Museum of Art; Chris Atkins and Lizabeth Dion at the Museum of Fine Arts, Boston; John Larson at the Oriental Institute of the University of Chicago; Therese Babineau at the Phoebe Apperson Hearst Museum of Anthropology at the University of California, Berkeley; Pat Woods at the Saint Louis Art Museum; Charles Kline at the University of Pennsylvania Museum of Archaeology and Anthropology, Philadelphia; and Kate Lau at the Walters Art Museum, Baltimore.

On the Hallie Ford Museum of Art staff, I would like to thank collections assistant Lisa Rindfleisch, research assistant David Roberts, education consultant Ron Crosier, preparator Bruce Black, administrative assistant Carolyn Harcourt, security officer Frank Simons, receptionists Molly Fitzsimmons and Megan Jensen, and custodian Peggy Flores, for their help with various aspects of the exhibition, publication, and tour. I am further indebted to Patricia Alley for her editorial comments and Kristen Allman for assembling the manuscript in its final form. As always, graphic designer Phil Kovacevich and editor Laura Iwasaki have created a beautifully designed and carefully edited book.

At the Boise Art Museum, I would like to thank executive director Tim Close, curator of art Sandy Harthorn, curator of education Andrea Potochick, registrar Kathy Bettis, and preparator Ron Walker, among others, for their support of the project from the get-go and for agreeing to participate in the exhibition, publication, and tour.

Additional financial support for the exhibition and publication has been provide by the Wyss Foundation, the Oregon Arts Commission, the National Endowment for the Arts, and the City of Salem (through the City of Salem's Transient Occupancy Tax Funds), and we are most grateful to them for their belief in our ability to carry out such an ambitious and important project.

Finally, and by no means least, I would like to thank our anonymous donor (you know who you are). Without your unconditional friendship and unyielding support over the past two years, *In the Fullness of Time: Masterpieces of Egyptian Art from American Collections* would never have come to fruition.

JOHN OLBRANTZ
The Maribeth Collins Director
Hallie Ford Museum of Art
Willamette University

In *the* Fullness *of* Time

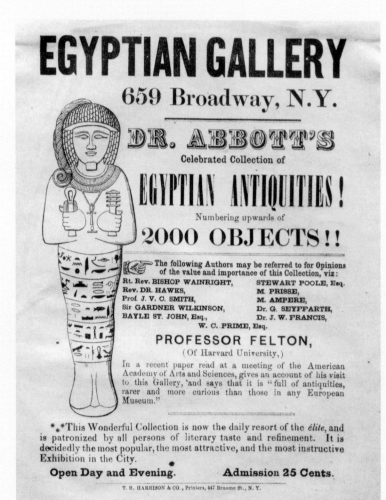

(Fig. 1) Advertisement for an exhibition of Henry Abbott's collection of Egyptian antiquities at the Stuyvesant Institute in New York, c. 1853–54.

Innocents Abroad:
Collectors, Curators, and the Rise of
Egyptian Collections in the United States

By John Olbrantz

Since the beginning of the nineteenth century, Americans have been fascinated and intrigued by the civilizations of the ancient Near East.[1] Although Americans did not begin fieldwork in Egypt until the turn of the twentieth century, a number of earlier intrepid visitors—adventurers, soldiers, missionaries, and tourists—brought back stories that captured the country's imagination and objects that eventually found their way into American museums. Among the earliest adventurers to visit Egypt were John Ledyard (1751–1788), a friend of Thomas Jefferson's who may have been sent to Egypt by the ever-curious Jefferson to report on its antiquities and who died in Cairo in 1788; a Captain Barthow, who is thought to have guided two British travelers up the Nile in 1812; and George English (1787–1828) and Luther Bradish (1783–1863), two Americans from Massachusetts who served as unlikely members of the Egyptian army in the 1820s.

As early as the end of the eighteenth century, a number of small Egyptian collections began to find their way into American museums.[2] The Peabody Museum in Salem, Massachusetts, founded in 1799, lays claim to being the first institution to acquire and display Egyptian antiquities in the United States, although the Library Society of Charleston, South Carolina, founded in 1748, is reported to have owned a handful of Egyptian artifacts and to have displayed an Egyptian mummy. The first Egyptian item accessioned into the Peabody collection was a mummified ibis donated by a Captain Apthorp in the early 1800s. In the following decade, Captain Nathaniel Page donated a carved wooden bird, while Lieutenant Thomas Tanner contributed a group of six wooden *shawabti* figures. Through-out the 1810s and 1820s, the ancient Egyptian collection of the Peabody Museum grew to include amulets, additional *shawabti* figures, and bits and pieces of mummified remains brought back to the United States by seafarers who had visited Egypt and other exotic ports.

Mummies, in particular, seem to have captivated the imagination of nineteenth-century American audiences. Several Egyptian mummies became part of the curiosities displayed at the legendary Peale family museums in Philadelphia, Baltimore, and New York in the 1810s and 1820s.[3] These items were later acquired by the great American showman and impresario Phineas T. Barnum (1810–1891), who displayed them at his huge American Museum in New York until they were destroyed by fire in 1865. Another mummy, presented to the City of Boston by a Dutch merchant from Smyrna in the early 1820s, was a permanent, if improbable, fixture at Massachusetts General Hospital for many years.

During the 1830s and 1840s, a number of private collections began to develop in the United States. In 1832, Colonel Mendes Cohen (c. 1790–1847), of Baltimore, visited Europe and Egypt, eventually returning to the United States with a collection of 680 Egyptian antiquities. In 1884, Cohen's collection was donated by his heirs to Johns Hopkins University, where it formed the foundation for the school's Egyptian collection. Similarly, during the mid-1830s, John Lowell Jr. (1799–1836), of Lowell, Massachusetts, traveled to Europe and the Middle East and acquired a number of Egyptian antiquities that were later donated to the Museum of Fine Arts, Boston. And in 1848, Dr. Henry Anderson (1799–1875), of New York, visited Egypt, where he assembled

a small but choice collection of Egyptian antiquities, which he subsequently gave to the New-York Historical Society.

In the early 1850s, an English physician named Henry Abbott (1812–1859) immigrated to the United States from Egypt and brought his splendid collection of Egyptian antiquities with him. Hoping to sell the collection for a handsome profit to the American collectors who were avid for Egyptian artifacts, he organized an exhibition at the Stuyvesant Institute in New York (Fig. 1). Unfortunately, his plan failed, and he returned impoverished to Egypt in 1854, precipitously abandoning his collection in the United States to offset mounting debts. The collection was eventually purchased for the New-York Historical Society in 1859–60, where it provided one of the first permanent displays of Egyptian antiquities in this country. The Brooklyn Museum of Art received the Abbott collection as a loan in 1937 and purchased it in 1948, a transaction that thereby formed a cornerstone of one of America's great Egyptian collections.

(Fig. 2) Detail, *Portrait of Charles Edwin Wilbour*, by Edwin Howland Blashfield, 1894.

During the latter half of the nineteenth century, a number of American missionaries, collectors, and adventurers visited Egypt and acquired pieces that would find their way into American museums. For example, the Reverend Chauncey Murch (1856–1907), a Presbyterian missionary assigned to pastoral duties in Luxor, assembled a collection of Egyptian antiquities that would be presented to the Metropolitan Museum of Art in 1910. Philanthropist Charles Freer (1856–1915), of Detroit, a collector of great taste, acquired a number of Coptic manuscripts that he would subsequently give to the Smithsonian Institution in Washington, DC. And, in the 1880s, Lieutenant

Commander Henry Gorringe (1841–1885), the naval officer who brought the Central Park obelisk from Alexandria, Egypt, to New York in 1881, assembled a small collection of Egyptian antiquities that would eventually be donated to the Metropolitan Museum of Art, the Brooklyn Museum of Art, and the Worcester Art Museum in Massachusetts.

From the 1880s to the 1920s, a number of Americans emerged in the field of Egyptology who had a profound impact on the development of Egyptian collections in the United States: Charles Edwin Wilbour (1833–1896), a New York newspaperman who, during the 1880s and until his death in 1896, assembled a substantial collection of Egyptian antiquities that would eventually be donated to the Brooklyn Museum of Art; George A. Reisner (1867–1942), an archaeologist whose work in Egypt helped expand the collections of the University of California, Berkeley, and the Museum of Fine Arts, Boston; James Henry Breasted (1865–1935), an Egyptologist who founded and guided the Oriental Institute at the University of Chicago during its formative years; Herbert E. Winlock (1884–1950), an archaeologist and curator who helped build the splendid collection of the Metropolitan Museum of Art; and Clarence S. Fisher (1876–1941), an architect turned archaeologist who excavated for the University of Pennsylvania from the late 1890s to the 1920s and helped build its remarkable Egyptian collection.

Charles Edwin Wilbour (Fig. 2) was born and raised in Rhode Island, attended Brown University in Providence, was admitted to the bar, and became a court reporter in New York in the early 1870s.[4] For a variety of political reasons, Wilbour left the United States in 1874 and moved to Europe, where he eventually studied Egyptology in Paris with Gaston Maspero (1846–1916) and in Heidelberg, Germany, with Auguste Eisenlohr (1832-1902). In 1880, Wilbour began spending his winters in Egypt, traveling up and down the Nile on his *dahabiyeh* (an Egyptian houseboat) and copying inscriptions from the tombs and

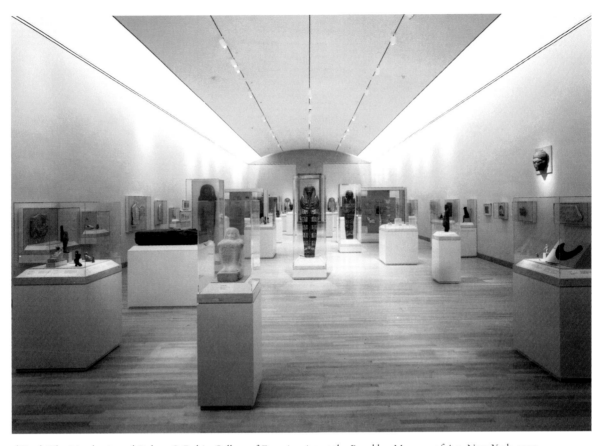

(Fig. 3) The Martha A. and Robert S. Rubin Gallery of Egyptian Art at the Brooklyn Museum of Art, New York, 1993.

temples he visited. In the process, he amassed a sizeable collection of Egyptian antiquities and books. When Wilbour died in 1896, his estate passed to his wife and children. In 1916, two years after his wife's death, Wilbour's daughters and son generously donated their father's entire collection and library to the Brooklyn Museum of Art and, at the same time, endowed a professorship in Egyptology in his memory at Brown University.

The Wilbour gift to the Brooklyn Museum of Art immediately elevated that institution to one of the preeminent repositories of Egyptian art in the United States. When Victor Wilbour, Charles's unmarried son, passed away in 1931, he stipulated in his will that a fund be established at the Brooklyn Museum of Art to preserve and enhance the Egyptian collection and library. Over the years, this permanently endowed fund has enabled the Egyptian Department to acquire significant works for the collection, publish books and catalogues on its diverse aspects, install or reinstall portions of the collection, acquire books and journals for the Wilbour Library, and support ongoing fieldwork in Egypt.

The Brooklyn Museum of Art has also benefited from outstanding curators over the years.[5] From 1932 to 1938 Jean Capart (1877–1947), a Belgian scholar, served as an honorary curator of Egyptian art. He is credited with a number of significant acquisitions and the publication in 1936 of Wilbour's *Travels in Egypt*, a collection of letters that provides a fascinating glimpse of life in Egypt during the 1880s and 1890s. Capart was assisted by John D. Cooney (1905–1982), a Harvard-trained Egyptologist who succeeded Capart as curator, serving from 1938 until his resignation in 1963. During his twenty-five-year tenure in the department, Cooney oversaw the organization of the collection and made a number of significant purchases, especially in the fields of Egyptian personal arts and Egyptian art of the Late Period.

From 1963 to 1982, the department was headed by Bernard V. Bothmer (1912–1993), who was originally hired as an assistant curator in 1956. Under his enthusiastic guidance and direction, the department continued to expand its collections, acquiring significant works from the Amarna and Late Periods. In addition, Bothmer and his staff published a number of exhibition catalogues on the collection, participated in numerous special exhibitions of Egyptian art, increased the number of loans from the department, and supported the department's excavation at the temple of Mut at Karnak. In recent years, the department has thrived in the capable hands of several of Bothmer's former students from the Institute of Fine Arts at New York University: Richard A. Fazzini, who currently serves as chairman, and James F. Romano and Edna R. Russmann, both of whom serve as curators.[6] In 1993, the department reinstalled a large portion of its Egyptian collection (Fig. 3); the second phase of the project will be completed in 2003.

(Fig. 4) George A. Reisner in his early fifties.

Considered to be one of the finest excavators of his day, George A. Reisner (Fig. 4) spent over forty years working as a field archaeologist in Egypt and exerted a significant influence on the development of two museums: the Phoebe Apperson Hearst Museum of Anthropology (formerly the Robert H. Lowie Museum of Anthropology), at the University of California, Berkeley, and the Museum of Fine Arts, Boston.[7] Born and raised in Indianapolis, Indiana, Reisner attended Harvard University and earned his Ph.D. in Semitic Languages and Literature in 1893. He was awarded a traveling fellowship to study Assyriology at Göttingen, Germany, but during his stay, became fascinated, like many others, with Egyptology. He made his first trip to Egypt in 1897 to catalogue the amulets and boat models in the Cairo Museum and, except for occasional trips back to the United States, spent the rest of his life in Egypt.

In 1899, Reisner met Phoebe Apperson Hearst (1842–1919), who was on tour in Egypt at the time and had decided to sponsor an archaeological dig (Fig. 5). Reisner was recommended to her, and for the next six years, he served as her field director. During the 1899 and 1900 seasons, he uncovered a large royal palace and cemetery at Deir el-Ballas and a Predynastic cemetery at el-Ahaiwah, both in Upper Egypt. After two seasons, he shifted his focus to a large cemetery at Naga el-Deir in Middle Egypt, and in 1903, he sent his assistant, Arthur C. Mace (1874–1928), to open up a concession at the royal cemetery at Giza. Reisner worked at Giza for another two years. When Hearst decided she could no longer support the project, the excavation became a joint project of Harvard University and the Museum of Fine Arts, Boston.

Hearst also sponsored an expedition by two British scholars, Bernard P. Grenfell (1869–1926) and Arthur S. Hunt (1871–1934), to Tebtunis, in the Faiyum region in Lower Egypt, and as a result of their work, she acquired papyri, sculpture, and funerary equipment from the Ptolemaic and Roman Periods for the University of California. These items, plus the thousands of objects excavated by Reisner at Deir el-Ballas, el-Ahaiwah, Naga el-Deir, and Giza, would form the foundation for the Egyptian collection at the Phoebe Apperson Hearst Museum of Anthropology, one of the finest collections of its kind in the United States.[8]

The Museum of Fine Arts, Boston, which was founded in 1870, received its first major gifts of Egyptian art from the collection of the Reverend C. Granville Way in 1872.[9] It obtained a second collection of Egyptian antiquities from the estate of John Lowell Jr. in 1875 and, during the 1880s and 1890s, added additional pieces to the collection as a result of its financial support of the Egypt Exploration Fund. By the early 1900s,

(Fig. 5) Phoebe Apperson Hearst (back row, second from left) at Giza, c. 1900.

however, the board of trustees and staff realized that enlarging their collection of Egyptian art necessitated supporting an archaeological dig in Egypt and assumed Hearst's sponsorship, in conjunction with Harvard University, of Reisner's excavation at Giza. Reisner was eventually appointed curator of Egyptian art in 1910, although he spent very little time in Boston over the next thirty-two years.

From 1906 until his death in 1942, Reisner excavated over 400 mastaba tombs at Giza. Among his most spectacular discoveries were the undisturbed tomb of Queen Hetepheres, mother of King Khufu, the mortuary temples of King Menkaure (Fig. 6), including statues of the king and his wife, and the bust of Prince Ankhhaf. In addition to his work at Giza, Reisner carried out extensive excavations at Naga el-Deir, Deir el-Bersha, Kafr Ghattati, Zawiyet el-Aryan, and

Koptos. From 1906 to 1932, he conducted an archaeological survey of Nubia and excavated a number of major sites between Aswan and Khartoum, including the royal necropolis at Kerma, several mud-brick forts at the Second Cataract, the great temple at Gebel Barkal, the royal cemeteries at el-Kurru and Nuri, where he unearthed over 1,000 *shawabti* figures of King Taharqo (Fig. 53), and a number of cemeteries at Meroë.

Dows Dunham (1890–1984), a Harvard-trained Egyptologist who excavated with Reisner from 1914 to 1928, succeeded him as curator of the Egyptian Department in 1942. During the 1940s and early 1950s, Dunham worked on cataloguing and publishing the vast amount of material excavated by Reisner. He resigned in the mid-1950s to publish Reisner's work in Nubia and the Sudan, and his assistant, William Stevenson Smith (1907–

(Fig. 6) Harvard University–Museum of Fine Arts, Boston, excavation at the valley mortuary temple of King Menkaure at Giza, 1910.

1969), took his place. Over the next decade, Smith, a prodigious scholar and writer, published several catalogues and monographs on different aspects of the collection.[10] In addition, he wrote one of the definitive textbooks in the field, *The Art and Architecture of Ancient Egypt*. Smith was succeeded by William Kelly Simpson, who, during the 1970s and 1980s, continued to publish the collection, directed a number of field projects in Egypt, including a study of the wall decoration in the mastaba tombs at Giza, increased the number of loans from the department, and participated in several major exhibitions of Egyptian art. From 1986 to 1988, the department was headed by Edward Brovarski and, since 1989, has been led by Rita E. Freed, another one of Bernard Bothmer's former students from the Institute of Fine Arts at New York University.

If Reisner was considered the finest American-born excavator of his day, James Henry Breasted (Fig. 7) was arguably the finest American-born historian of ancient Egypt of his time.[11] Born and

raised in Chicago, Breasted initially studied theology at the Chicago Theological Seminary but soon transferred to Yale University, in Connecticut, where he studied Hebrew with William Rainey Harper (1856–1906). Harper, who was laying the groundwork for the University of Chicago at the time, told Breasted that if he studied Egyptology in Germany, he could have the first American professorship in Egyptology upon his return. Determined to seize this golden opportunity, Breasted sailed for Germany in the fall of 1891, earned his Ph.D. in Egyptology in 1894 at Berlin under Adolph Erman (1854–1937), got married, and, after a honeymoon in Egypt (where else?), took Harper up on his offer.

During the late 1890s and early 1900s, Breasted taught Egyptology at the University of Chicago, published a number of scholarly articles and books in the field, lectured to service and social clubs throughout the Midwest, and served as assistant director of the Haskell Oriental

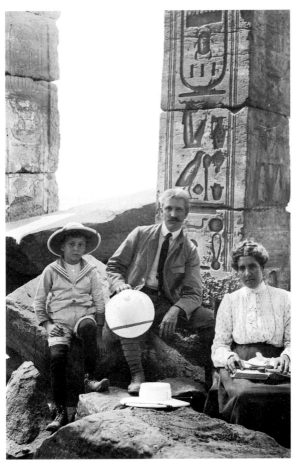

(Fig. 7) James Henry Breasted (center) flanked by his son, Charles, and wife, Frances, at the Amada temple in Nubia, 1906.

immense satisfaction, Rockefeller agreed to support the university's excavation at Bismaya (ancient Adab) in Iraq. From 1906 to 1908, he provided further support that enabled Breasted to travel to Egypt with his wife, Frances, and young son, Charles, to conduct an epigraphic and photographic survey of the tombs and temples of Nubia and the Sudan. Unfortunately, during the 1910s, Rockefeller's support waned somewhat. Breasted continued to write, lecture, and teach, and, in 1916, he published *Ancient Times*, his popular textbook for young people. In 1919, with Rockefeller's financial support, he founded the Oriental Institute at the University of Chicago as a laboratory for the study of the civilizations of the ancient Near East and served as its director until his death in 1935. During the 1920s and early 1930s, the institute sponsored a number of excavations in Egypt and the Near East, and in 1931, it opened a new facility to house its growing collections. Over the years, the Oriental Institute has benefited from strong leadership and support and remains a major center for the collection, preservation, exhibition, and interpretation of ancient Egyptian civilization in the United States.[12]

Museum, the forerunner of the Oriental Institute. The Haskell Oriental Museum was founded by Harper, who had been appointed president of the University of Chicago, to house the school's collection of Egyptian and Ancient Near Eastern art (Fig. 8). Under Breasted's guidance and direction, it acquired a number of objects from various Egyptian sites, including Naucratis, the Faiyum, Abydos, Dendera, and Thebes. Most of these pieces were excavated by the brilliant British archaeologist Sir William Matthew Flinders Petrie (1853–1942) and were obtained through the University of Chicago's financial support of the Egypt Exploration Fund, which funded Petrie's ongoing excavations.

In 1902, President Harper approached philanthropist John D. Rockefeller (1839–1937) about setting up an Oriental research fund. To Harper's

The Metropolitan Museum of Art, one of the foremost museums in the world, acquired its first Egyptian objects in the 1870s and early 1880s and, in 1886, purchased from the Egyptian government a number of items from the tomb of Sennedjem at Thebes.[13] Throughout the 1880s and 1890s, the Metropolitan made annual subscriptions to the Egypt Exploration Fund, for which, in return, it received a number of spectacular Egyptian objects for its permanent collection. By the turn of the century, however, the infinitely ambitious financier J. Pierpont Morgan (1837–1913), who had just been elected president of the board of trustees, felt that the Metropolitan needed its own Egyptian Department and hired the brilliant young Egyptologist Albert M. Lythgoe (1868–1934) to head the department. Lythgoe had been the curator of Egyptian art at the Museum of Fine Arts, Boston, as well as a professor of Egyptology at Harvard.

(Fig. 8) Special exhibition at the Haskell Oriental Museum, Chicago, 1922.

Taking his cue from Morgan, who believed the Metropolitan should mount its own excavations in Egypt, Lythgoe opened up a concession at the pyramids of Lisht, about thirty-five miles south of Cairo, in 1906. The following year, he inaugurated a second dig at el-Kharga Oasis, and in 1910, he established a permanent base of operation in Luxor, site of the ancient city of Thebes. After Morgan's death in 1913, the department's major benefactor was Edward S. Harkness (1874–1940), who made several significant donations over the years, including an Old Kingdom mastaba tomb of an official named Perinebi in 1913 and a portion of the private collection of Lord Carnarvon (1866-1923) in 1926. Between 1906 and 1936, the Egyptian Department maintained concessions at Lisht, el-Kharga Oasis, Wadi Natrun, Hierakonpolis, and Thebes. What the department failed to unearth from the ground, it purchased on the art market or acquired as gifts. By the time Lythgoe retired in 1929, the Metropolitan Museum of Art could rightfully claim its collection of Egyptian art to be one of the finest, if not the finest, in the United States.

Part of the reason for the success of the Metropolitan Museum of Art during the 1910s and 1920s was Herbert E. Winlock (Fig. 9), Lythgoe's affable assistant curator in the Egyptian Department from 1906 to 1929 and the Metropolitan's principal field archaeologist in Egypt during that time period.[14] Born and raised in Washington, DC, where his father was assistant director of the Smithsonian Institution, Winlock became fascinated with Egyptology as a young boy and often spent hours studying the mummies at the Smithsonian. At Harvard, he studied with Lythgoe, who was so impressed with his young student's enthusiasm and acumen that he invited him to join the staff of the Egyptian Department and participate in its first excavation at the pyramids at Lisht.

At Lisht, Winlock and the Metropolitan staff excavated the pyramids of two Middle Kingdom kings, Amenemhat I and his son, Senwosret I, and at el-Kharga Oasis, they excavated the temple of Hibis and a number of nearby cemeteries. It was at Thebes, however, that Winlock made his most exciting and spectacular discoveries. In 1920, he discovered a Middle Kingdom tomb of an official named Meketre, which included a number of superbly crafted tomb models that offered an intimate glimpse of daily life in ancient Egypt. In addition, he and the Metropolitan staff helped clear the site of the mortuary temple of Queen Hatshepsut at Deir el-Bahri and excavated a number of Middle Kingdom cemeteries that provided some of the first insights we have into the private lives of the ancient Egyptians. A brilliant archaeologist and superb writer, Winlock had the ability to bring ancient history to life through his popular articles and books.

(Fig. 9) Herbert E. Winlock, reproduced from the guest book of the Metropolitan Museum of Art's Egyptian Expedition House in Thebes, c. 1920s.

When Albert Lythgoe retired in 1929, Winlock became curator of the Egyptian Department and, in 1932, director of the Metropolitan Museum of Art. Although he clearly missed active fieldwork, Winlock threw himself into the directorship and served with distinction until 1939, when a stroke forced him to step down as both curator and director. Winlock's retirement corresponded with the end of the Metropolitan's fieldwork projects in Egypt, and during the 1940s and early 1950s, under the direction of Ambrose Lansing (1891–1959), the focus of the department shifted to cataloguing and publishing the collection.[15] William C. Hayes (1903–1963) followed as curator of the Egyptian Department from 1952 until his untimely death in 1963 and published an extensive two-volume guide to the Egyptian collection, *The Scepter of*

Egypt: A Background for the Study of Egyptian Antiquities in the Metropolitan Museum of Art. Hayes was succeeded by Henry G. Fischer, who was largely responsible for obtaining the temple of Dendur for the Egyptian collection in 1967 (Fig. 10), and Nora Scott (1905–1994), who served as curator from 1970 to 1972. During the 1970s and 1980s, the Egyptian Department was headed by Christine Lilyquist, who helped bring *The Treasures of Tutankhamun* to the United States in 1977 and 1978 and oversaw the reinstallation of the Egyptian galleries in the 1980s. Since 1991, Dorothea Arnold has served as the department's Lila Acheson Wallace Curator.

Like the University of California and the University of Chicago, the University of Pennsylvania began to acquire an Egyptian collection in the 1890s.[16] Sara Yorke Stevenson (1847–1921), the first curator of the University of Pennsylvania Museum of Archaeology and Anthropology (and, notably, the first woman to hold the position of curator of an Egyptian collection in the United States), made a trip to Egypt in 1898 to open up a concession at Dendera, but serious fieldwork in Egypt did not begin until 1907, when Philadelphia philanthropist Eckley Brinton Coxe Jr. (1872–1916) sponsored an expedition to Nubia. In the meantime, Stevenson brilliantly enhanced the Egyptian collection through her support of the Egypt Exploration Fund, which provided the collection with a number of objects from Memphis, Dendera, Hierakonpolis, and the royal cemeteries of Abydos. Stevenson would serve with energy and distinction until 1905, when she was replaced by David Randall-MacIver (1873–1945), an Egyptologist who had worked with Petrie at Dendera and Abydos in the 1890s and who excavated a number of Nubian sites between the First and Second Cataracts during the early 1900s.

Clarence S. Fisher (Fig. 11) was originally trained as an architect at the University of Pennsylvania but turned to archaeological fieldwork early in his career. He excavated in Iraq during the late 1890s and assisted Reisner in Egypt and Palestine in the following decade. In 1914, he was appointed

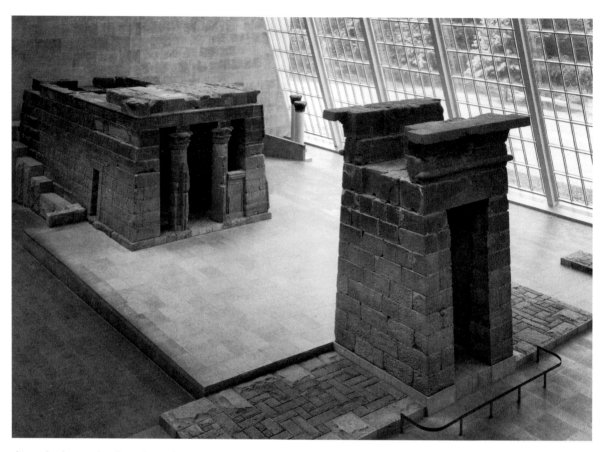

(Fig. 10) The temple of Dendur at the Metropolitan Museum of Art, New York, 1979.

curator of the Egyptian Section at the University of Pennsylvania Museum of Archaeology and Anthropology, and the following year, he was sent to Egypt to excavate one of the royal cemeteries at Giza. At about the same time, he opened up a concession at Memphis, where he discovered the royal palace of Merneptah, the successor of Ramesses II. From 1915 to 1918, he excavated a large provincial cemetery at Dendera that helped provide a fascinating picture of daily life during the Middle Kingdom. Finally, from 1921 to 1923, he spent two seasons at Dra Abu el-Naga, a Theban cemetery near the Valley of the Kings, where he excavated the New Kingdom tombs of several high-ranking officials and the mortuary complex of Amunhotep I and his wife, Ahmose Nefertari.

In addition to his fieldwork, Fisher played a major role in the permanent installation of the Egyptian collection in the new Coxe Wing in 1926 (Fig. 12), although he had resigned a year earlier due to a growing rift between him and director George Byron Gordon (1870–1927). Fisher was replaced as curator in 1931 by the English scholar Battiscombe Gunn (1883–1950), who helped organize the collection for easier access by researchers and scholars. Gunn resigned in 1934 to become chair of Egyptology at Oxford University, and Hermann Ranke (1878–1953) succeeded him in 1938. During his twelve years as curator, Ranke stressed publication of earlier field reports and produced the first catalogue of the collection. Rudolf Anthes (1896–1985) headed the department from 1950 to 1963, and when Anthes retired, he was replaced in 1964 by David O'Connor, who would serve as curator for the next thirty-one years. Under O'Connor's enlightened direction and leadership, the department reinstalled a number of its galleries, improved storage conditions for the collection, initiated a number of traveling exhibitions, supported loans

from the collection, and maintained an active schedule of fieldwork and publication. David P. Silverman succeeded O'Connor in 1995 and has continued the tradition of scholarship and fieldwork established one hundred years earlier by Eckley Brinton Coxe Jr., whose endowed chair in Egyptology he also currently holds.

Not every museum developed its Egyptian collection through fieldwork.[17] Indeed, most American museums acquired Egyptian antiquities through their support of the Egypt Exploration Fund, which was established with great practical foresight and imagination in 1882 by the Englishwoman Amelia B. Edwards (1831–1892) to support ongoing fieldwork in Egypt.[18] For an annual subscription ranging from $50 to $100 per year, each participating museum received a portion of the following season's finds. Among the American museums and academic institutions to participate in the Egypt Exploration Fund from the 1890s to the 1920s were the Museum of Fine Arts, Boston; Yale University; the Metropolitan Museum of

Art; the Brooklyn Museum of Art; the University of Pennsylvania; the Carnegie Museum of Natural History;[19] the Walters Art Gallery; the Detroit Institute of Arts; the Cleveland Museum of Art; the University of Chicago; the Field Museum of Natural History; and the Smithsonian Institution in Washington, DC.

Still other museums developed significant collections of Egyptian art because of a particular director, curator, or donor. During the 1920s, for example, under the leadership of William R. Valentiner (1880–1958), the Detroit Institute of Arts began to acquire examples of Egyptian art and even hired Howard Carter (1873–1939) to serve as its agent in Egypt.[20] Among the notable Egyptian pieces acquired through donation or purchase during this time period were a statuette of a cat from the Late Period (Fig. 21) and a portrait of a woman from the second century A.D. In 1968, William H. Peck was hired as the first curator of ancient art, and during the past thirty-four years, he has been actively engaged in acquisition,

(Fig. 11) Clarence S. Fisher at Dendara, 1916.

(Fig. 12) The Coxe Egyptian Wing at the University of Pennsylvania Museum of Archaeology and Anthropology, Philadelphia, 1926.

exhibition, publication, and fieldwork; since the late 1970s, Peck and Richard Fazzini from the Brooklyn Museum of Art have co-directed a joint expedition to the temple of Mut at Karnak.

Similarly, under the direction of Sherman E. Lee, the Cleveland Museum of Art began to acquire outstanding examples of Egyptian art in the 1950s and 1960s and, in 1963, hired John Cooney as its first curator of ancient art. Cooney had served as curator of Egyptian art at the Brooklyn Museum of Art and brought the same high level of scholarship and connoisseurship to his new position.[21] He was succeeded by Arielle P. Kozloff, who organized several marvelous exhibitions at the Cleveland Museum of Art during the 1980s and early 1990s and helped lay the

groundwork for the publication of the first catalogue to the collection. The publication was brought to fruition under the direction of Lawrence M. Berman, who succeeded Kozloff as curator and has since moved on to the Museum of Fine Arts, Boston. The department is currently in the capable hands of Kenneth J. Bohač.

Over the years, a number of donors have played a singular role in developing outstanding collections of Egyptian art throughout the United States. During the late nineteenth and early twentieth centuries, for example, Baltimore businessman and collector William Walters (1819–1894) developed an encyclopaedic collection of art and opened an art gallery in which to display his collection.[22] Upon his death, his collection passed to

(Fig. 13) Professor Mark Sponenburgh at the mortuary temple of Ramesses III at Medinet-Habu, 1952.

his son, Henry (1848–1931). Each spring, Henry Walters sailed to Europe, where, like his father before him, he purchased works for his collection. In Paris, antiquities dealer Dikran Kelekian (1868–1951) provided him with a number of superb examples of Egyptian art, including a seated statue of Senwosret III from the Twelfth Dynasty and an Egyptian gilded mummy mask from the Roman Period. Walters bequeathed the gallery and collection to the city council and mayor of Baltimore in 1931. In 1934, the gallery reopened as the Walters Art Gallery. During the mid-1940s, the brilliant German Egyptologist Georg Steindorff (1861–1951) was hired to research and publish the collection of Egyptian sculpture. Over the years, the department of ancient art has benefited from a number of outstanding curators, and in 2001, Regine Schulz was retained as the first Egyptologist to head the department. Schulz came to Baltimore from the

University of Munich, where she still holds a professorship in Egyptology.

Other museums have benefited from the generosity of donors. William Randolph Hearst (1863–1951), the newspaper publisher and son of Phoebe Apperson Hearst, donated a number of significant Egyptian items to the Los Angeles County Museum of Art in the late 1940s when James Henry Breasted Jr. (1908–1983), son of the famous Egyptologist, was director. From the late 1940s to the 1960s, Richard E. Fuller (1897–1976), who founded the Seattle Art Museum in the early 1930s and directed it for nearly forty years, acquired several important pieces of Egyptian art for its collection, including a head of the god Amun and a funerary stela of Udjarenes.[23] At about the same time, during the 1950s and 1960s, the Saint Louis Art Museum developed an excellent collection of Egyptian, Near Eastern, Greek, and Roman art, thanks to the generosity and support of local collectors and donors.[24] In recent years, under the guidance and direction of curator Sidney M. Goldstein, it has acquired several remarkable pieces, including an Egyptian wooden figure from the early Sixth Dynasty and the mummy case of Amen-Nestawy-Nakht from the Ptolemaic Period.

Even the Hallie Ford Museum of Art at Willamette University in Salem, Oregon, has a small collection of Egyptian art. Donated by Professor Mark Sponenburgh and his late wife, Janeth Hogue Sponenburgh, in 1990, the collection includes a processional relief from the south forecourt of the mortuary temple of Queen Hatshepsut at Deir el-Bahri, a *shawabti* figure, an Egyptian eye inlaid with alabaster and basalt, a bronze statuette of Ptah, the Egyptian god of artists, two wooden funerary masks from the Late Period, several Coptic textiles, and a Coptic relief from the sixth century A.D.. Sponenburgh collected these pieces in Egypt beginning in the 1950s, when he was a Fulbright Research Scholar at the American Research Center in Egypt (Fig. 13). He spent two years in Egypt conducting research and writing scholarly essays on Egyptian

sculpture, and it was during this time that he became acquainted with John Cooney, Alexander Badawy (1913–1986), and a number of other prominent Egyptologists active at mid-century.

Although most American museums are no longer able to mount large-scale field excavations or amass enormous collections of Egyptian art as they did in the past, there is still a tremendous amount of work that remains to be done. Objects that have been tucked away in attics and store-rooms for decades are finally seeing the light of day, and collections that have remained unpublished for years are being published for the first time. Many curators and educators are developing new strategies to interpret the art and culture of ancient Egypt in light of recent scholarship in the field, while others are organizing exhibitions that make their collections available to new audiences in places like Salem, Oregon, and Boise, Idaho, where few examples of Egyptian art exist. While the romantic era of large-scale field excavations and spectacular discoveries that characterized nineteenth-century and early twentieth-century Egyptology has largely passed, American museums continue to demonstrate their commitment to the field of Egyptology through the ongoing research, preservation, exhibition, and interpretation of their Egyptian collections.

John Olbrantz is the Maribeth Collins Director of the Hallie Ford Museum of Art at Willamette University in Salem, Oregon.

ENDNOTES

1. For two excellent introductions to the history of American Egyptology, see John A. Wilson, *Signs and Wonders Upon Pharaoh: A History of American Egyptology* (Chicago: University of Chicago Press, 1964), and Nancy Thomas, ed., *The American Discovery of Ancient Egypt* (Los Angeles: Los Angeles County Museum of Art and the American Research Center in Egypt, 1995).

2. For an early history of American Egyptology, see especially Gerry D. Scott III, "Go Down into Egypt: The Dawn of American Egyptology," in Thomas, *The American Discovery of Ancient Egypt* , 36–47.

3. The Peale family museums are discussed at length in Edward P. Alexander, *Museum Masters: Their Museums and Their Influence* (Nashville, Tenn.: The American Association for State and Local History, 1983), 43–77.

4. For further information on Charles Edwin Wilbour, see Wilson, *Signs and Wonders Upon Pharaoh*, 82–83, 87, 88, 92–93, 101–109, 204, 232.

5. For an overview of the Egyptian Department at the Brooklyn Museum of Art, see Richard A. Fazzini, "The Brooklyn Museum's Egyptian Collection," in Richard A. Fazzini et al., *Ancient Egyptian Art in the Brooklyn Museum* (Brooklyn, N.Y.: Brooklyn Museum, 1989), vii–x.

6. An excellent recent guide to the Egyptian collection at the Brooklyn Museum of Art is Richard A. Fazzini, James F. Romano, and Madeline E. Cody, *Art for Eternity: Masterworks of Egyptian Art* (Brooklyn, N.Y.: Brooklyn Museum of Art, 1999).

7. For further information on George A. Reisner, see Wilson, *Signs and Wonders Upon Pharaoh*, 132, 142, 144–150, 153, 166–169, 182, 183, 195, 207, 228.

8. For a brief guide to the Egyptian collection at the Phoebe Apperson Hearst Museum of Anthropology, see Albert B. Elsasser and Vera-Mae Fredrickson, *Ancient Egypt* (Berkeley, Calif.: Robert H. Lowie Museum of Anthropology, University of California, 1966).

9. For an excellent introduction to the early history of the Egyptian collection at the Museum of Fine Arts, Boston, and the various field projects undertaken by the Egyptian Department under George A. Reisner, see Dows Dunham, *The Egyptian Department and Its Excavations* (Boston: Museum of Fine Arts, 1958).

10. For further information on the Egyptian collection at the Museum of Fine Arts, Boston, see William Stevenson Smith, *Ancient Egypt as Represented in the Museum of Fine Arts, Boston*, 6th ed., rev. (Boston: Museum of Fine Arts, 1960).

11. For further information on James Henry Breasted, see Charles Breasted, *Pioneer to the Past: The Story of James Henry Breasted, Archaeologist* (Chicago: University of Chicago Press, 1943), and Wilson, *Signs and Wonders Upon Pharaoh*, 129, 130–143, 144, 145, 150, 164, 166, 169, 170–72, 174, 177, 179, 181–184, 192, 206, 215.

12. For a brief introduction to the Egyptian collection at the Oriental Institute at the University of Chicago, see Leon Marfoe, "Egypt," in *A Guide to The Oriental Institute Museum* (Chicago: The Oriental Institute Museum, University of Chicago, 1982), 9–39, and Emily Teeter, "The Egyptian Gallery of The Oriental Institute Museum," *Near Eastern Archaeology* 62, no. 2 (1999): 93–100.

13. An excellent survey of the Egyptian Department at the Metropolitan Museum of Art appears in Calvin Tompkins, *Merchants and Masterpieces: The Story of the Metropolitan Museum of Art* (New York: E. P. Dutton, 1970), 135–148.

14. For further information on Herbert E. Winlock, see Wilson, *Sign and Wonders Upon Pharaoh*, 122–123, 142–143, 184–192, 211–212, 232–233.

15. The best introduction to the Egyptian collection at the Metropolitan Museum of Art is still William C. Hayes, *The Scepter of Egypt: A Background for the Study of Egyptian Antiquities in the Metropolitan Museum of Art*, 2 vols. (New York: Metropolitan Museum of Art, 1953–59).

16. For a thorough history of the Egyptian Section at the University of Pennsylvania Museum of Archaeology and Anthropology, see David O'Connor and David Silverman, "The University Museum in Egypt," *Expedition* 21, no. 2 (1979): 4–8; David O'Connor and David Silverman, "The University, the Museum, and the Study of Ancient Egypt," *Expedition* 21, no. 2 (1979): 9–12; David O'Connor and David Silverman, "The Museum in the Field," *Expedition* 21, no. 2 (1979): 13–32; David O'Connor and David Silverman, "The Egyptian Collection," *Expedition* 21, no. 2 (1979): 33–43; and David P. Silverman, "Introduction," in David P. Silverman, ed., *Searching for Ancient Egypt: Art, Architecture, and Artifacts from the University of Pennsylvania Museum of Archaeology and Anthropology* (Ithaca, N.Y.: Cornell University Press, 1997), 10–23.

17. For an overview of fieldwork undertaken by American museums and other academic institutions, see especially Nancy Thomas, "American Institutional Fieldwork in Egypt, 1899–1960," in Thomas, *The American Discovery of Ancient Egypt*, 48–75, 248–255.

18. The history of the Egypt Exploration Society has been thoroughly documented in T. G. H. James, ed., *Excavating in Egypt: The Egypt Exploration Society, 1882–1982* (Chicago: University of Chicago Press, 1982).

19. For further information on the Egyptian collection at the Carnegie Museum of Natural History, see David R. Watters and Diana Craig Patch, "Pittsburgh Discovers Ancient Egypt," *Carnegie Magazine* 58, no. 2 (March/April 1986): 30–37, and Diana Craig Patch, *Reflections of Greatness: Egyptian Art at the Carnegie Museum of Natural History* (Pittsburgh: Carnegie Museum of Natural History, 1990).

20. For further information on the Egyptian collection at the Detroit Institute of Arts, see William H. Peck, "The Present State of Egyptian Art in Detroit," *Connoisseur* 175, no. 706 (December 1970): 265–273, and William H. Peck, *The Detroit Institute of Arts: A Brief History*, (Detroit: Detroit Institute of Arts, 1991), 70, 81, 86, 109, 121, 149, 174–175, 176.

21. For further information on the development of the Egyptian collection at the Cleveland Museum of Art, see Arielle P. Kozloff, "History of the Egyptian Collection of the Cleveland Museum of Art," in Lawrence M. Berman et al., *The Cleveland Museum of Art: Catalogue of Egyptian Art* (New York: Hudson Hills Press, 1999), 1–29.

22. For further information on William and Henry Walters and the Walters Art Gallery, see William R. Johnston, *William and Henry Walters, The Reticent Collectors* (Baltimore: The Johns Hopkins University Press, 1999), and Gary Vikan et al., *The Walters Art Gallery* (London: Scala Books, 1997).

23. For information on the Egyptian collection at the Seattle Art Museum, see Emily Teeter, *Egyptian Art in the Collection of the Seattle Art Museum* (Seattle: Seattle Art Museum, 1988).

24. For an introduction to the Egyptian and Ancient Near Eastern collections of the Saint Louis Art Museum, see Sidney M. Goldstein, "Egyptian and Near Eastern Art," *The Saint Louis Art Museum Bulletin* 19, no. 4 (Summer 1990).

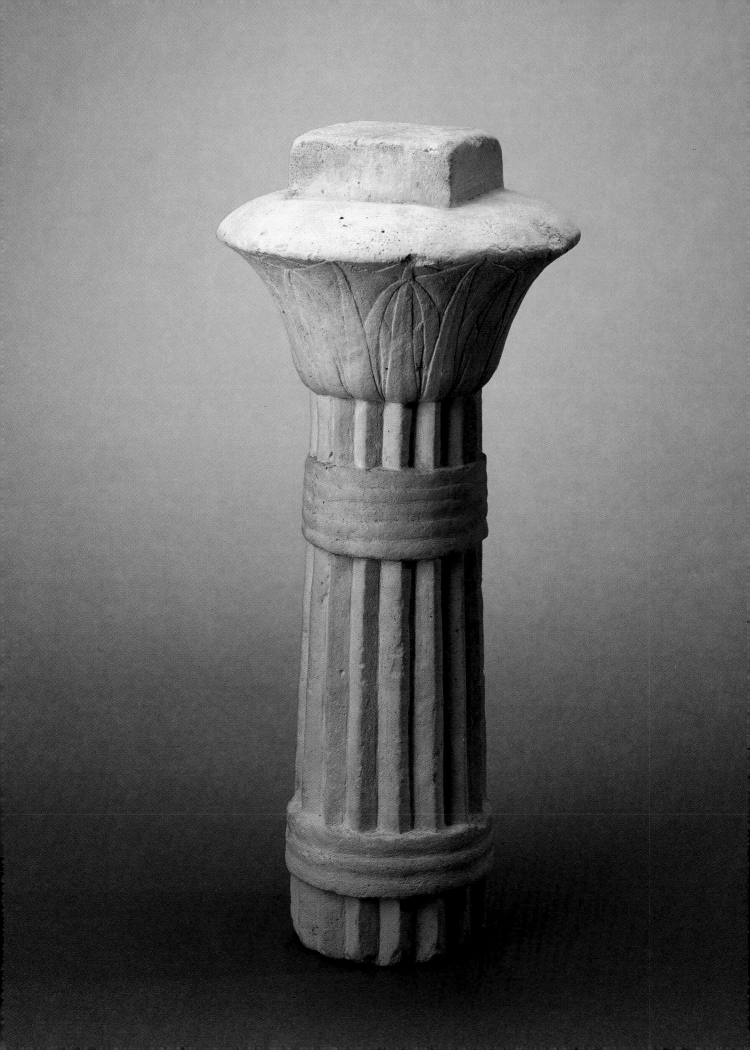

IN THE FULLNESS OF TIME: MASTERPIECES OF EGYPTIAN ART FROM AMERICAN COLLECTION

BY JAMES F. ROMANO

EGYPT—the word summons forth images of omnipotent pharaohs, shriveled mocha-colored mummies, Tutankhamun's treasures, and massive limestone pyramids defying the inexorable passage of time. For thousands of years, tourists and scholars have felt the lure of ancient Egypt and traveled to the Nile Valley. Alexander the Great marveled at the wisdom of Egypt's sages, and Napoleon brought dozens of France's leading savants to copy the images in her ruined tombs and temples. The French novelist Gustave Flaubert wrote of the ineffable awe we feel when first confronted by the Great Pyramid, the last of the world's Seven Wonders: "…It is like a cliff, like a thing of nature, a mountain—as though it had been created just as it is, and with something terrible about it, as if it were going to crush you."[1] Frederick Douglass, visiting Egypt in 1887, framed his reactions in biblical terms when he remarked: "It is no small thing to see the land of Joseph and his brethren and from which Moses led the children of Abraham out of the house of Bondage."[2] Even cultural icons of our own era— Princess Diana, Muhammad Ali, Gloria Steinem, the Grateful Dead, and Bill Walton—have traveled to Egypt to behold the remnants of her former greatness.

Of all Egypt's legacies, none speaks more eloquently or emphatically to a modern audience than the culture's incomparable artistic achievements. People unable to distinguish a Vermeer from a van Gogh have no difficulty recognizing a work of ancient Egyptian art. Why are these creations so identifiable? Why do they fascinate and delight us more than two thousand years after the last pharaoh ruled the Nile Valley? Part of the reason stems from a natural appreciation of quality; the finest Egyptian statues, paintings, and reliefs achieve a level of artistic accomplishment rarely rivaled in human history. Egyptian artists' facility for color and line, their seemingly effortless mastery of obdurate stone, and their skill in designing harmonious compositions command our praise and admiration. To understand Egyptian art's continuing appeal, we must look deeper, to a level below it's obvious technical proficiency. We must try to understand what the artists hoped to accomplish, what information they tried to communicate, what methods they used to convey their message, and, ultimately, why ancient Egyptian art *had* to look the way it does.[3]

We must understand what Egyptian art *isn't*. First, it isn't a window in time revealing how most Egyptians lived. The statues, paintings, and reliefs that form the core of *In the Fullness of Time*, like most works of Egyptian art, belonged to members of the elite, perhaps no more than 2 percent of the population. Scenes of well-fed peasants working merrily in the fields, for example, represent what the ruling class believed, or wished to believe, was an accurate depiction of life. Because these images were meant to provide conventional points of reference for wealthy tomb owners throughout eternity, they are far more idealized than graphic. Even more important, Egyptian art is not Western. Egyptian art undoubtedly influenced Greek sculptors who in turn inspired their Roman counterparts, but this artistic stimulus moved in one direction only, from northern Africa to southern Europe. There is nothing European about Egyptian art; there is much Egyptian about early European (Greek and

(Fig. 14) *Votive column.* Provenance not known. Ptolemaic Period, 305–30 B.C. Limestone. 24.5 x 11.7 x 11.7 cm (9^{11}/$_{16}$ x 4^5/$_8$ x 4^5/$_8$ in.). Collection of The Saint Louis Art Museum. Purchase. 201:1924.

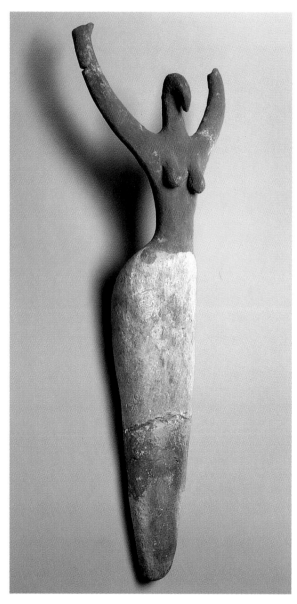

(Fig. 15) *Female figurine.* Ma'mariya. Predynastic Period, Naqada II Period, c. 3650–3300 B.C. Terracotta, painted. 34.1 x 11.4 x 5.4 cm (13⅜ x 4¹¹⁄₁₆ x 2¼ in.). Collection of the Brooklyn Museum of Art. Museum Collection Fund. 07.447.502.

everything that is distinctly Egyptian. For Egypt, the sea marks the limits of a world—of an African world…we must expect to find little of Platonic thought in this world.[4]

This different way of thinking manifests itself in limitless ways. For our subject, ancient Egyptian art, the most telling contrast with contemporary Western cognition is that the Egyptians' language had no equivalent for our word "art." When we visit a museum exhibition such as *In the Fullness of Time* or examine ancient reliefs on the walls of Egypt's tombs and temples, we tend to judge them from a Western perspective, as works of art designed to excite our admiration or imagination. They rarely fail. But these goals would have been meaningless to ancient craftsmen. They did not fashion objects to garner public esteem; in fact, some of the finest statues and reliefs were walled away in tombs, accessible only to spirits. Egyptian artists viewed their creations as functional, as components of an intricate religious system seeking to come to terms with man's place in this world and in the afterlife. Egyptian art was embedded in Egyptian religion.

What kinds of Egyptian art does this exhibition explore? Circumstances limit our options. Certainly Egyptian architecture merits a place in any discussion of artistic expression, but with the exception of the temple of Dendur in the Metropolitan Museum of Art in New York (Fig. 10), there are no large-scale Egyptian structures visible in the Western Hemisphere. Small architectural models exist (Fig. 14), but they hardly give a sense of the grandeur conveyed by Egypt's immense pyramids and extensive temple complexes.[5] Nor will we encounter any tomb paintings. They are best left in their rightful homes: the walls of ancient burial sites. We must limit our inquiry to four types of artistic expression: three-dimensional sculpture in stone, wood, metal, and clay; relief, or two-dimensional sculpture; painting on portable objects; and portable objects themselves, which constitute the so-called personal arts.

Roman) art. The art of the ancient Nile Valley was the product of a culture and a way of thinking profoundly different from European-based traditions. More than forty years ago, the French Egyptologist Serge Sauneron wrote:

> *We like to talk about "Mediterranean civilization" and include in it all that is beautiful and great in the vicinity of the sea. But when the Nile empties…into the [Mediterranean], it leaves far behind*

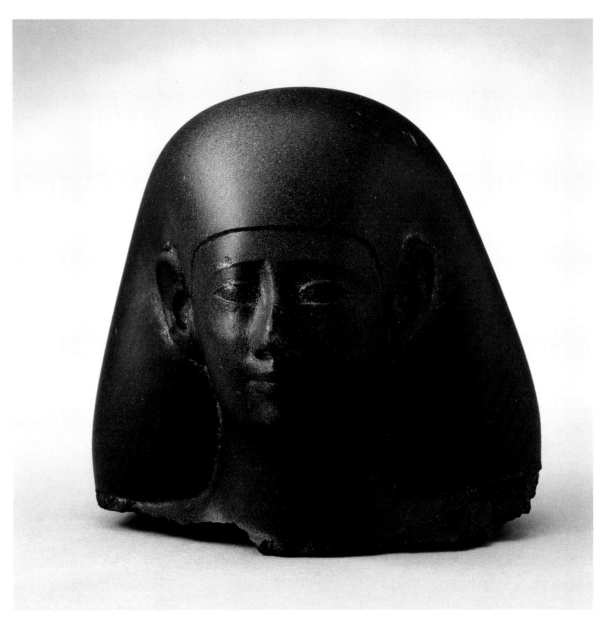

(Fig. 16) *Head of a man.* Provenance not known. Late Period, Dynasty 30, 381–343 B.C. Graywacke. 10 x 10.4 x 8.7 cm (3^{15}/$_{16}$ x 4^{1}/$_{8}$ x 3^{7}/$_{16}$ in.). Collection of The Saint Louis Art Museum. Gift of J. Lionberger Davis. 215:1954.

SCULPTURE

Egyptian artists first fashioned images in human form more than five thousand years ago (Fig. 15).[6] The earliest examples were modeled in clay or carved in ivory; by the beginning of the First Dynasty (c. 3000–2800 B.C.), skilled sculptors had perfected the ability to carve life-size figures in stone. Not surprisingly, stone would remain the principal medium for sculpture throughout Egyptian history. It was everywhere. The cliffs flanking the Nile still hold limitless quantities of limestone, and random outcroppings of sandstone are found to this day. Masons hewed other stones from isolated locations across the country. Aswan, for example, was the site of a great granite quarry, and alabaster came from the Hatnub in the eastern desert near the site of El Amarna. Graywacke (commonly, and incorrectly, called "schist") was popular with Egyptian sculptors throughout the Pharaonic Period (Figs. 16, 17). This fine-grained gray rock, which resembles

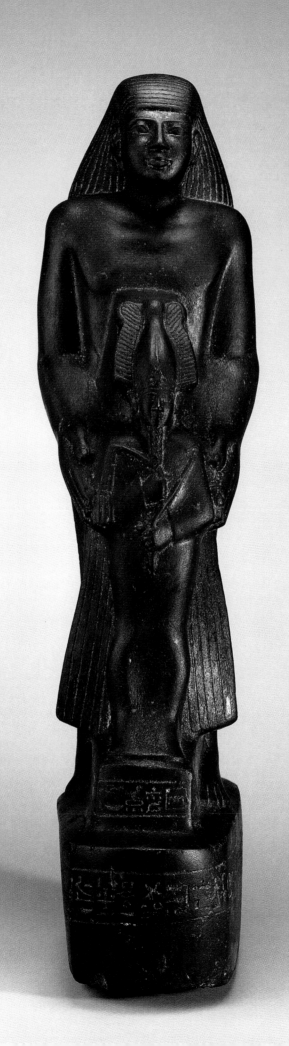

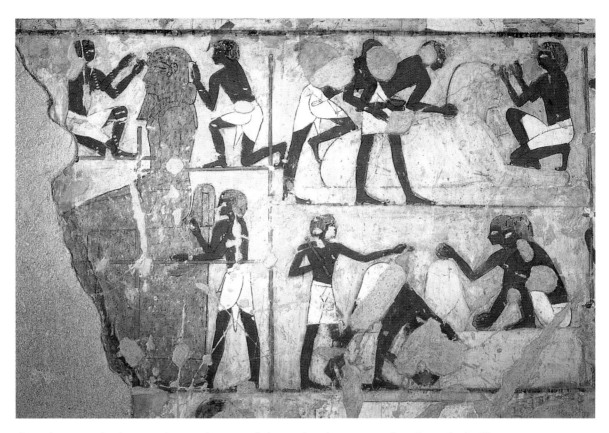

(Fig. 18) A team of sculptors working on the statue of a king and a sphinx; painting from the tomb of Rekhmire in western Thebes (tomb 100), Dynasty 18.

slate, was quarried in the Wadi Hammamat, a dried riverbed extending from the Upper Nile Valley through the eastern desert to the Red Sea. Enterprising stonecutters even ventured beyond Egypt's borders in search of attractive materials. For example, they quarried gneiss, a hard, foliated, dark stone, in the western deserts of Nubia, the land south of Egypt.[7]

Masons shipped stone in rectangular blocks to sculptors' workshops, where teams of artists sketched the statue's intended form on the front, back, and sides of the block. By the Middle Kingdom (c. 2008–1721 B.C.), this sketch had been formalized into a grid precisely drawn to maintain consistency of proportions from one statue to the next. Sculptors next employed stone and copper tools to achieve a roughed-out version of the finished work. They then cut away the remaining grid squares. Finally, a master

carver smoothed down the statue's surface, particularly the body, with an abrasive such as sand and highlighted important details including facial features, clothing, and jewelry (Fig. 18). Some statues, especially those made of limestone, received a thin layer of plaster to which the artists applied paint. Over the millennia, most of this pigment has disappeared, but some statues preserve enough to hint at their original polychrome appearance (Fig. 19).

Craftsmen began manufacturing wooden statues at least as early as Dynasty 1, but for several reasons, relatively few examples remain.[8] The nature of the material accounts for some of this scarcity. Egyptian trees, mostly sycamore, acacia, and tamarisk, yield small rough pieces of wood not well suited to large-scale sculpture. Wooden figures tended to be diminutive and thus less likely to survive. Larger examples had to be constructed

(Fig. 17) *Statue of Irt-horru holding a statue of Osiris.* Karnak, temple of Amun. Late Period, late Dynasty 26, c. 595–525 B.C. Graywacke. 56 x 16 x 22 cm (22 x 6¼ x 8⅝ in.). Collection of The Walters Art Museum, Baltimore. 22.215.

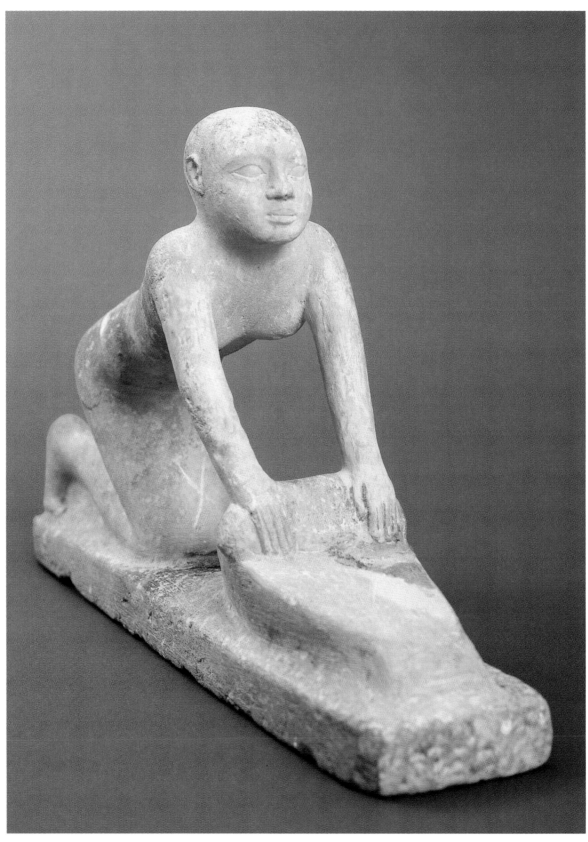

(Fig. 19) *Statuette of woman grinding grain*. Giza, cemetery 1000, tomb 213. Old Kingdom, Dynasty 5, c. 2500–2350 B.C. Limestone, painted. 19.7 x 7.5 x 31 cm (7³⁄₄ x 2¹⁄₈ x 12¹⁄₈ in.). Collection of the Phoebe Apperson Hearst Museum of Anthropology, University of California, Berkeley. 6-19812.

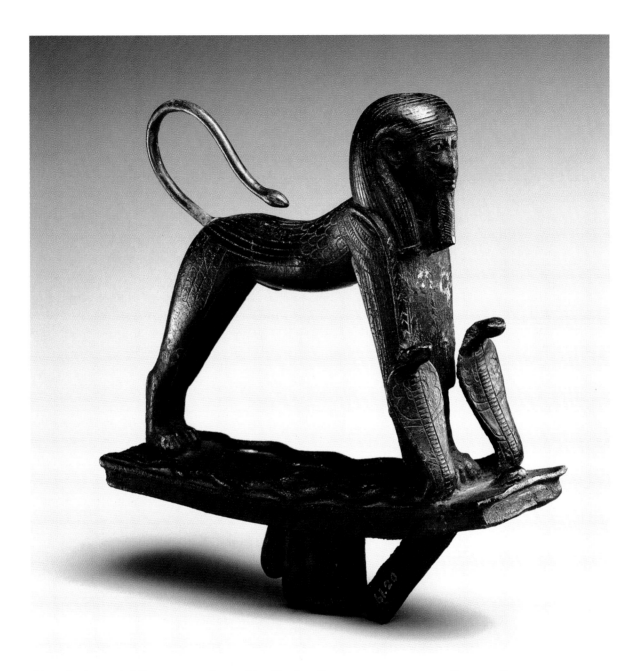

(Fig. 20) *Sphinx standard.* Provenance not known. New Kingdom, Dynasty 19, c. 1292–1190 B.C. Bronze. 12.8 x 12.3 x 3.7 cm (5 1/16 x 4 15/16 x 1 7/16 in.). Collection of the Brooklyn Museum of Art. Charles Edwin Wilbour Fund. 61.20.

from separate pieces—torso, limbs, head, base— and glued together by craftsmen. Once the adhesive dried out, these composite figures fell apart, leaving fragments that were rarely collected and preserved by early archaeologists. Insects and decay also destroyed much of what otherwise might have endured.

Metal sculpture has a long history as well; an early text mentions a copper statue made for King Khasekhemwy of the Second Dynasty (c. 2800–2675 B.C.). Copper (in reality, arsenic bronze, a natural alloy of copper and arsenic) remained the principal material for metal sculpture until the late Middle Kingdom or shortly thereafter, when smiths mastered the technique of alloying copper and tin to produce bronze. From that time onward, the overwhelming majority of small metal statues consisted of bronze and were produced by a technique known as the lost-wax method (Figs. 20, 21).[9] The artist began by modeling an image in wax. Next, he pressed a layer of

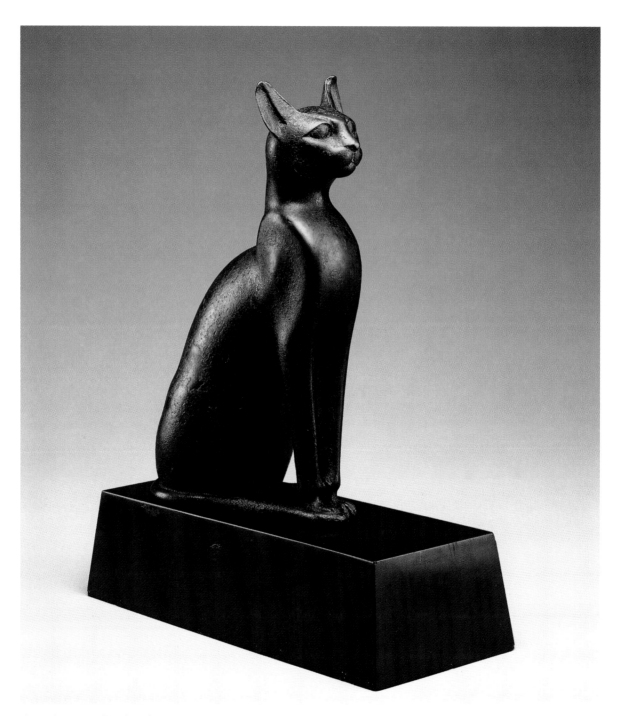

(Fig. 21) *Statuette of sacred cat of Bastet.* Provenance not known. Late Period, Dynasty 26, 664–525 B.C. Bronze. 26.3 x 8.3 x 15.2 cm (10³⁄₈ x 3¹⁄₄ x 6 in.). Collection of The Detroit Institute of Arts. Gift of Mrs. Lillian Henkel Haass and Miss Constance Haass. 31.72.

damp clay onto the wax matrix and heated the mass so the wax melted and the clay hardened, leaving a negative impression, or mold, of the original wax figure. Molten bronze was carefully poured into the mold. After the metal cooled, craftsmen broke the mold and removed the sculpture. For large sculptures, metalworkers preferred core casting. The procedure is much like the lost-

wax method except that the wax is modeled on a sand or clay core. The artist covered the core and wax with clay and then inserted thin metal pins through the clay and into the core. When the combined mass was fired, the wax melted off, leaving a wafer-thin space between the core and the hardened clay. A smith then introduced molten bronze into the intervening cavity,

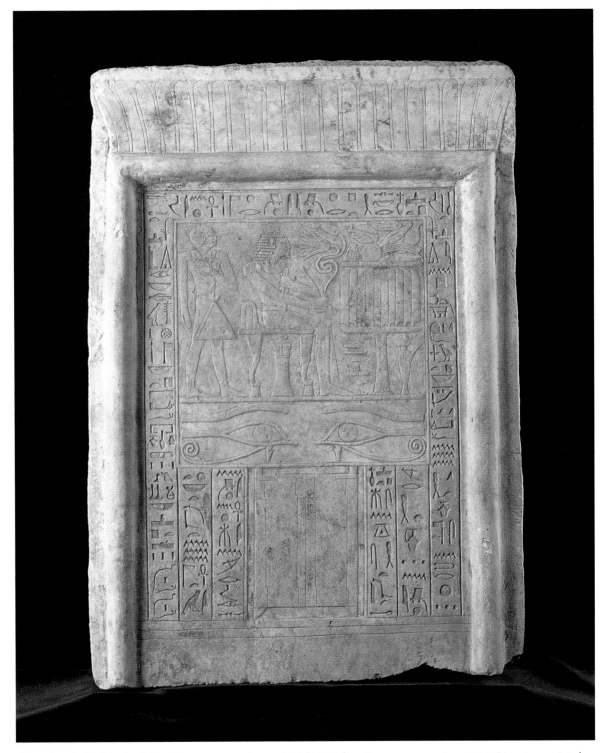

(Fig. 22) *Stela of Ankhi and Neferhotep.* Provenance not known. Middle Kingdom, Dynasty 12, c. 1938–1759 B.C. Limestone, painted. 60 x 43 x 10.2 cm (23⅝ x 17 x 4⅛ in.). Collection of the Phoebe Apperson Hearst Museum of Anthropology, University of California, Berkeley. 5-352.

and when the metal cooled, he broke the mold and extracted the resulting hollow sculpture. Core casting has one significant advantage over the lost-wax method: it dramatically reduces the amount of metal required to manufacture a statue. Costly gold and silver statues were also made in molds using either lost-wax or core-casting techniques.

(Fig. 23) *Offering table.* Provenance not known. Roman Period, 2nd–3rd century A.D. Limestone. 28 x 21 x 6 cm (11 x 8¼ x 2⅜ in.). Collection of The Metropolitan Museum of Art. Purchase, Mr. and Mrs. Dulaney Logan Gift, 1969. 69.31.1.

RELIEF

Relief work constitutes the second major category of Egyptian art presented in the exhibition.[10] A relief is the projection of figures or forms either from or into a flat surface. The Egyptians produced two types of relief, raised and sunk. To create raised relief, artists cut away the background surrounding the subject so that it appears to rise from the plane (Figs.. 22, 23). Sunk relief reverses the process: the image is formed by cutting into the stone or wood, essentially sinking the figure beneath the surface (Figs. 24, 25). The Egyptians developed raised relief quite early, circa 3650–3000 B.C., in the second half of the Predynastic Period; sunk relief was invented in the Fourth Dynasty (c. 2625–2500 B.C.). At first glance, sunk relief would appear to be the more practical and efficient of the two types. Because it requires less cutting, it can be executed far more quickly and economically. Also, sunk relief images were below the surface, making them less susceptible to damage. Finally, when seen in strong sunlight, the contours of sunk relief images are much easier to

distinguish than those of raised relief figures, which seem to wash out and lose their sharpness. It is true that buildings produced in a hurry tended to feature sunk relief decoration (Fig. 26) and that carvers working on the exterior walls tended to favor sunk relief, but we cannot detect a consistent pattern in the use of raised and sunk relief.[11] Any attempt to formulate a rule applicable to all Egyptian relief art, especially a rule predicated on modern conceptions of practicality, tells us more about our own conception of art than that of the Egyptians.

Before beginning a wall relief, the artist had to polish the surface to an even, workable finish. If the facade was particularly rough, he might apply a smooth coating of plaster. Next, he covered the area with a network of thin red lines to serve as a guide in drawing the figures he would eventually carve. He produced these lines by dipping a string into red paint, stretching it across the stone surface, and then snapping it against the wall, where it left a straight line. He repeated the process

(Fig. 24) *Stela of Satnetinheret.* Naga el-Deir. First Intermediate Period, Dynasty 9–mid–Dynasty 11, c. 2130–2008 B.C. Limestone, painted. 66 x 40 x 11.5 cm (26 x 15$\frac{3}{4}$ x 4$\frac{1}{2}$ in.). Collection of the Phoebe Apperson Hearst Museum of Anthropology, University of California, Berkeley. 6-19881.

(Fig. 25) *Relief of people scaring away birds.* Hermopolis Magna, pylon of Ramesses II. New Kingdom, Dynasty 18, Amarna Period, reign of Akhenaten (c. 1353–1336 B.C.). Limestone, painted. 21 x 54 x 3.2 cm (8$\frac{1}{4}$ x 21$\frac{1}{4}$ x 1$\frac{3}{8}$ in.). Collection of the Brooklyn Museum of Art. Charles Edwin Wilbour Fund. 60.1973.

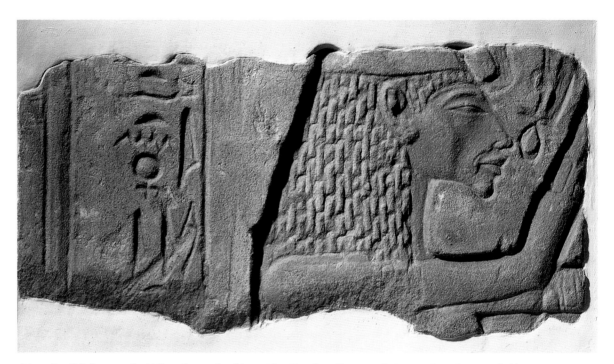

(Fig. 26) *Relief of Queen Nefertiti.* Karnak, temple of Aten. New Kingdom, Dynasty 18, Amarna Period, reign of Akhenaten (c. 1353–1336 B.C.). Sandstone, painted. 21 x 42 x 2.3 cm (8¼ x 16⁹⁄₁₆ x ⅞ in.). Collection of the Brooklyn Museum of Art. Gift of Christos G. Bastis. 78.39.

many times, forming a checkerboard pattern across the area to be carved (Fig. 27). There was no need to worry about the lines marring the finished wall; they were either cut away during final carving or covered with paint. Next, a team of artisans, supervised by the master draftsman, drew preliminary sketches on the wall, using the guidelines for assistance. Once these drawings had been executed and approved, carving began. In the first stage of the process, the edges of the images remained sharp, usually at a 90° angle to the surface. Later, a master carver smoothed off the outlines and added minute details with a fine chisel or other sharp tool. Finally, the entire surface was covered with plaster, the figures were redrawn, and paint was applied.

The key to executing two-dimensional renderings was the checkerboard of thin red lines applied before drawing began. In the Old Kingdom (c. 2675–2170 B.C.), these served primarily as guidelines to aid the artist in achieving harmonious placement of details, especially body parts. By the Middle Kingdom (c. 2008–1721 B.C.), the original system of guidelines had evolved into a true grid

(Fig. 27) Grid lines on a figure in the tomb of Ramose in western Thebes (tomb 55), Dynasty 18.

(Fig. 28) *Sketch of King Akhenaten.* El Amarna. New Kingdom, Dynasty 18, Amarna Period, reign of Akhenaten (c. 1353–1336 B.C.). Limestone, ink. 11.6 x 13.8 x 2.3 cm (4⁹/₁₆ x 5⁷/₁₆ x ⅞ in.). Collection of the Brooklyn Museum of Art. Gift of the Egypt Exploration Society. 36.876.

that regularized representations of the human form. At this time, standing figures were always eighteen squares high; the bottom of the kneecap began at the top of square 5, the eye was placed in the center of square 17; and the shoulders marked the conjunction of squares 15 and 16. Seated figures followed the same prescribed scheme (Fig. 22), but they were drawn on a more compact fourteen-square grid. Over the millennia, the accepted model for the human figure changed, and the grid system changed with it. In the Amarna Period (c. 1353–1336 B.C.) of late Dynasty 18, for example, images of Akhenaten featured longer necks, wider hips, and more attenuated legs than had appeared previously

(Fig. 28). These changes inspired Akhenaten's artists to invent a new twenty-square grid. Much later, during the Twenty-fifth Dynasty (c. 760–656 B.C.), a twenty-one-square grid became the norm.[12]

Egyptian draftsmen regularly placed figures on ground lines rather than making them appear to hover in space. We can first document this tendency, albeit intermittently, in the Naqada II Period (c. 3650–3300 B.C.; Fig. 29), but most renderings from that remote Predynastic era fail to incorporate ground lines. Certainly by the founding of Dynasty 1 (c. 3000 B.C.), ground lines had become standard elements of Egyptian two-dimensional art. When decorating a single wall,

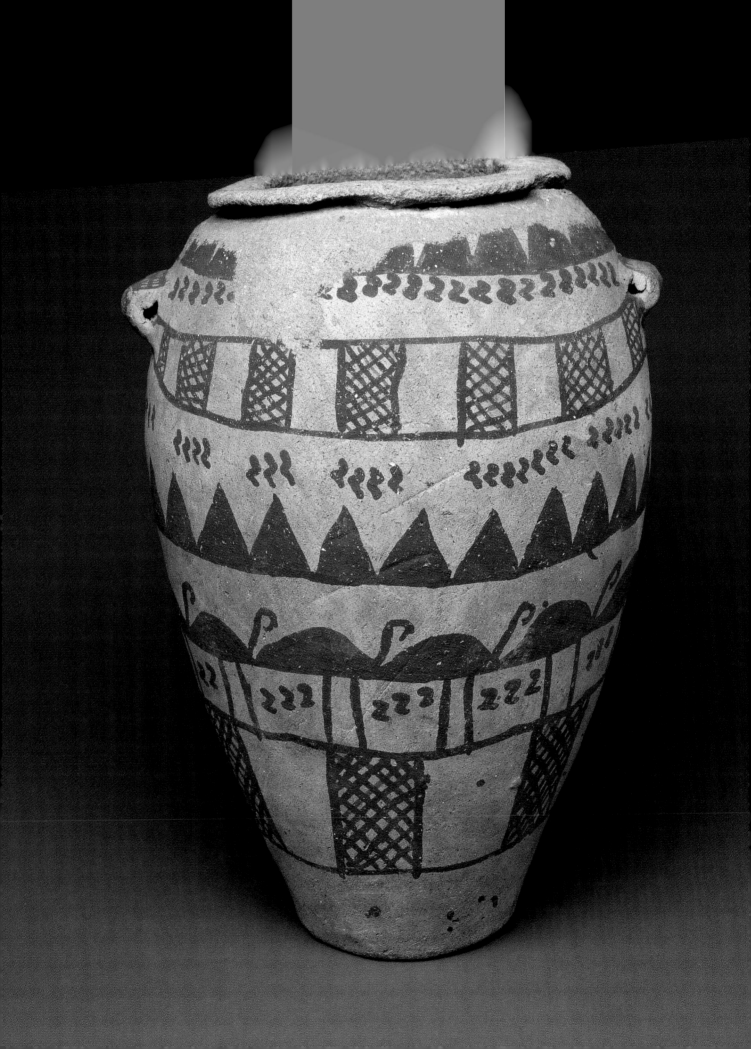

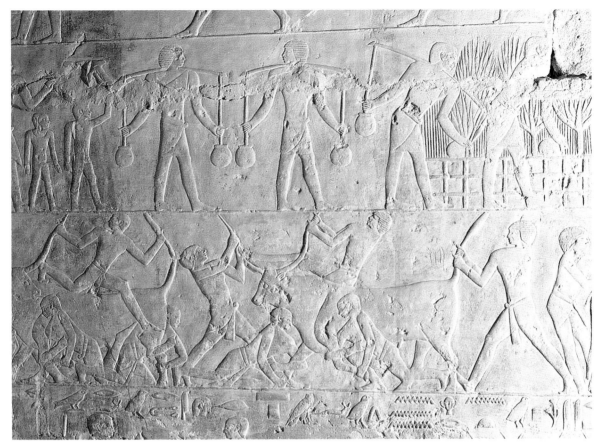

(Fig. 30) Agricultural scenes carved in relief from the tomb of Mereruka at Saqqara, Dynasty 6.

artists extended the ground line across the entire surface. For multiple scenes, they divided the wall into several rows or registers, each defined by a straight ground line (Fig. 30).

Ancient artists most often used relief decoration on architectural surfaces such as temple and tomb walls, but the technique was also employed in the production of stelae, inscribed slabs usually associated with a tomb (Figs. 22, 24). Stelae frequently depict the tomb owner and members of the immediate family; accompanying texts provide biographical and genealogical information and enumerate lists of offerings provided for the deceased throughout eternity. Craftsmen also decorated portable objects such as drinking vessels or jewelry with relief images (Fig. 31).

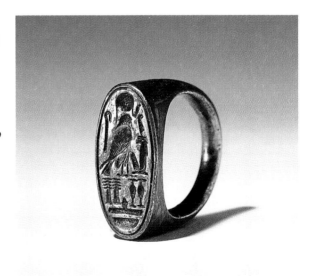

(Fig. 31) *Ring of King Ramesses IV.* Provenance not known. New Kingdom, Dynasty 20, reign of Ramesses IV (c. 1156–1150 B.C.). Silver. Width 2.3 cm (⅞ in.). Collection of the Brooklyn Museum of Art. Charles Edwin Wilbour Fund. 37.727E.

(Fig. 29) *Vase with water birds.* Ma'mariya. Predynastic Period, Naqada II Period, c. 3650-3300 B.C. Terracotta, painted. 20.4 x 15.3 x 7 cm (8¹⁄₁₆ x 6 x 2¾ in.). Collection of the Brooklyn Museum of Art. Charles Edwin Wilbour Fund. 07.447.441.

PAINTING

Egyptian painters began their work in much the same way as relief carvers.[13] They first smoothed the rock face they wished to decorate, sometimes applying a layer of plaster or stucco to produce an unfailingly uniform surface. To delineate guidelines or grids, they employed the efficient method of a string dipped in red paint. Preliminary sketches enabled them to map out their compositions before applying color. Egyptian painters worked with a very limited palette: red, yellow, brown, blue, green, white, and black. They prepared their pigments from natural substances ground into powder, mixed with water, and combined with a gummy adhesive. Red was derived from iron oxide or red ocher; yellow from yellow ocher or orpiment, a natural arsenic trisulfide; and brown from russet ocher. To make blue paint, craftsmen crushed pieces of frit (a man-made compound of copper, silica, and calcium) or azurite (a copper carbon-ate mined in the Sinai). From the same source came malachite, another copper carbonate, the principal ingredient in green pigment. Most white paint consisted of gypsum or whiting; black came from a carbon source, often soot collected from old cooking pots or the remains of fires (Fig. 32). Innovative artists could combine any of these traditional pigments to fabricate colors not normally found in the Egyptian palette—they mixed white gypsum and red ocher, for example, to produce pink. The most common type of brush consisted of a mass of palm fibers that were bundled together and tied with a cord.

When an Egyptian artist began to paint, his approach to his craft was regulated by a rule familiar to any preschooler with a crayon and a coloring book: "Don't go outside the lines." For the ancient painter, these restraining lines were the preliminary sketches drawn onto the tomb walls when the composition was still in the planning stage. From earliest times, a figure's outline,

(Fig. 32) Detail of painting from the tomb of Nakht in western Thebes (tomb 52), Dynasty 18.

42

(Fig. 33) Detail of painting from the tomb of Menena in western Thebes (tomb 69), Dynasty 18.

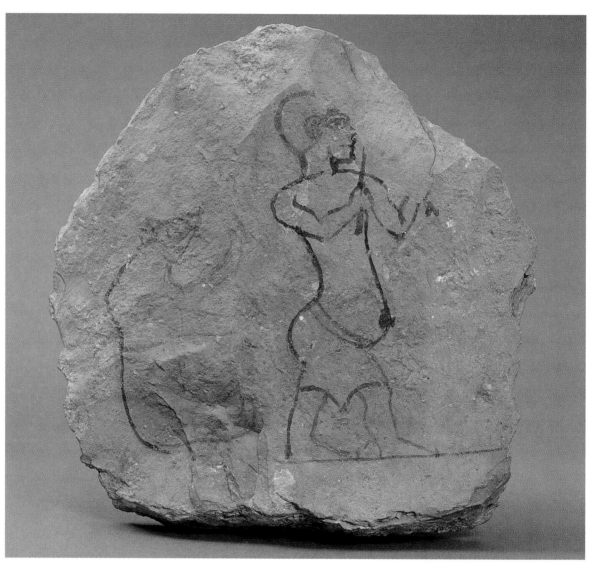

(Fig. 34) *Ostrakon of dwarf and bear.* Provenance not known. New Kingdom, Dynasty 19–20, c. 1292–1075 B.C. Limestone, ink. 21 x 21 x 7 cm (8¼ x 8¼ x 2⅞ in.). Collection of the Phoebe Apperson Hearst Museum of Anthropology, University of California, Berkeley. 6-15558.

rather than its interior detail, defined its existence (Fig. 29). If you look carefully at any full figure painted on a tomb wall, you will notice the contour rendered in black or red. Within these lines, artists applied broad flat masses of color. Finer details could then be added, but, almost without exception, in simple monochromatic applications; attempts at shading or color gradations were extremely uncommon. The resulting effect can be simultaneously vibrant and stiflingly formal (Fig. 33). To find any hint of spontaneity, you must seek out secondary images—drooping desert plants, anonymous mourners attending a funeral, tiny wisps of unruly, wind-blown hair—where the artist allowed himself to break free of rigid artistic constraints.

Fortunately, Egyptian painters left ample evidence of their spontaneous nature on *ostraka*, broken bits of painted limestone or pottery.[14] Some examples preserve what must have been practice sketches executed in a somewhat casual hand (Fig. 28). Others seem to reflect the artist's fascination with unusual subjects such as an Asian bear and an achondroplastic dwarf (Fig. 34). Thousands of years after these designs were painted, we can still sense the artist's pride in his command of the brush and his mastery of these exotic images.

(Fig. 35a,b,c) *Shawabti jars with lids.* Provenance not known.
New Kingdom, Dynasty 19–20, c. 1292–1075 B.C. Terracotta,
painted. Top to bottom: 29.4 x 22.2 x 11.6 cm ($11\frac{1}{2}$ x $8\frac{3}{4}$ x $4\frac{1}{2}$ in.);
23.2 x 22.7 x 12.1 cm ($9\frac{1}{8}$ x $8\frac{7}{8}$ x $4\frac{3}{4}$ in.); 28.5 x 23.4 x 11.5 cm
($11\frac{1}{4}$ x $9\frac{1}{4}$ x $4\frac{1}{2}$ in.). Collection of The Cleveland Museum of Art. Gift of
John Huntington Art and Polytechnic Trust, 1914. 1914.641 a–b, 1914.829
a–b, 1914.643 a–b.

Artistic confidence is also conveyed by the simple linear figures of funerary gods painted on the sides of three New Kingdom pottery jars (Fig. 35a,b,c). These jars belong to the fourth classification of antiquities represented in this exhibition: utilitarian items including but not restricted to jewelry (Figs. 31, 36, 37, 38); cosmetic equipment (Fig. 39); metal, stone, and ceramic vessels (Figs. 29, 40); and furniture (Fig. 41). Archaeologists and art historians have traditionally labeled such objects "minor arts" to distinguish them from the "major arts" of sculpture, relief, and painting. Recently, the less pejorative expression "personal arts" has been introduced to stress the more private aspects of these pieces.[15] A detailed discussion of Egyptian personal arts would fill a book many times the length of this volume, so we will restrict ourselves to general comments about the kinds of personal art included in this exhibition.

Although the popular mind often associates Egyptian creativity and skill with objects of grand scale such as pyramids and sphinxes, connoisseurs recognize that some of the ancient craftsmen's most impressive works, in terms of design and execution, were their extraordinary jewelry.[16] Many astonishing pieces survive from antiquity, and countless more appear on statues and in reliefs and paintings (Figs. 24, 33). Almost every Egyptian, from pharaoh to peasant, wore some form of jewelry, including bracelets, necklaces, earrings, anklets, and finger rings (Fig. 31). Kings and nobles owned scores of elaborate pieces made of gold and semiprecious stones, while a farmer might have a simple bracelet consisting of a drab rock tied to a cord. A few specialized forms of jewelry, such as beaded hip girdles, were worn exclusively by women. Most types, however, were not gender-specific.

The earliest examples, of Predynastic date, are simple bracelets and necklaces composed of a single row of perforated shells strung on a cord. By the end of the Predynastic, the Egyptians were

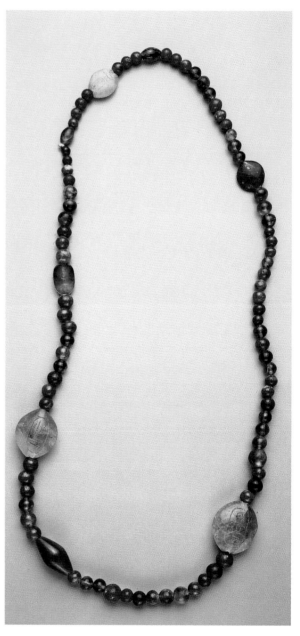

(Fig. 36) *Necklace.* Dendera, grave 13:098C. Middle Kingdom, Dynasty 12, reign of Senwosret I (c. 1919–1875 B.C.). Amethyst, carnelian. 36.8 x 4.4 x 1.5 cm (14½ x 1¾ x ⅝ in.). Collection of the University of Pennsylvania Museum of Archaeology and Anthropology, Philadelphia. Coxe Expedition, 1915. 29-66-813.

finding tiny gold pebbles along the riverbanks and converting the metal into jewelry. They soon developed techniques for extracting gold from riverine gravel or sand in the deserts east of the Nile; the method resembled the panning process used during the California gold rush of 1849. Although resourceful scouts identified many sources of gold in the eastern desert, the

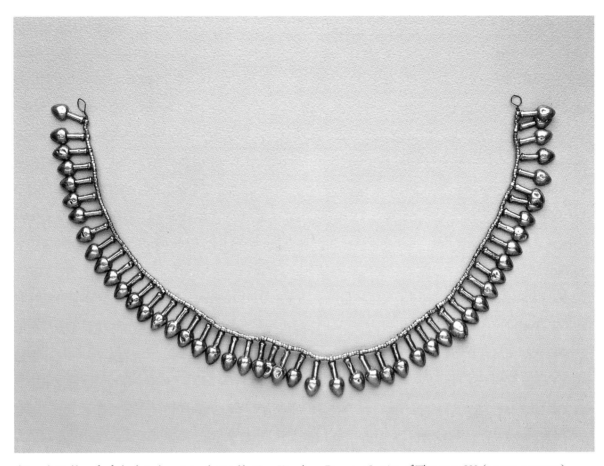

(Fig. 37) *Necklace of nefer-beads*. Sedment, tomb 254 (?). New Kingdom, Dynasty 18, reign of Thutmose III (c. 1479–1425 B.C.). Gold. 18.5 x 1.2 x 0.3 cm (7 x ½ x ⅛in.). Collection of the University of Pennsylvania Museum of Archaeology and Anthropology, Philadelphia. British School of Archeology, 1921. E.15789.

Egyptians eventually concentrated their mining activities in three locations: Koptos (a town near modern Luxor), Wawat, and Kush. These last two sites were in Nubia, the area south of Aswan, beyond ancient Egypt's border. There is strong evidence suggesting that "Nubia" derives from the Egyptian word for gold (*nub*) and the place name meant something like "Gold Land." Egyptian jewelers also worked with electrum and silver, but these materials were never as highly valued as gold.

Despite the Egyptian jeweler's skill with gold, however, it is his harmonious and imaginative use of colored stones that gives his creations their distinctive appearance. The most prized was lapis lazuli, a deep blue stone with characteristic white streaks and tiny flecks of gold. Lapis is not native to the Nile Valley; pieces had to be imported from Badakshan in Afghanistan. Blue or blue-green turquoise was often associated with veins of copper ore extracted in the Sinai. Ancient jewelers also favored carnelian, ranging in color from fiery red-orange to pale red. The Egyptians extracted it from many sources in the eastern desert and Nubia. Purple amethyst enjoyed great popularity during the Middle Kingdom (Fig. 36), when it was mined at a remote wadi (dried riverbed) about twenty miles southeast of Aswan.

The most skilled Egyptian jewelers used a cloisonné metalworking technique to combine several varieties of semiprecious stones in one article. The jeweler began by bending a thin metal strip—often gold—into the desired shape. He then soldered it at right angles to a flat metal surface, thus creating tiny cells, or cloisons. Next, precisely cut bits of stone such as carnelian or lapis lazuli were fitted into the cloisons and secured with an adhesive. By carefully designing the placement of

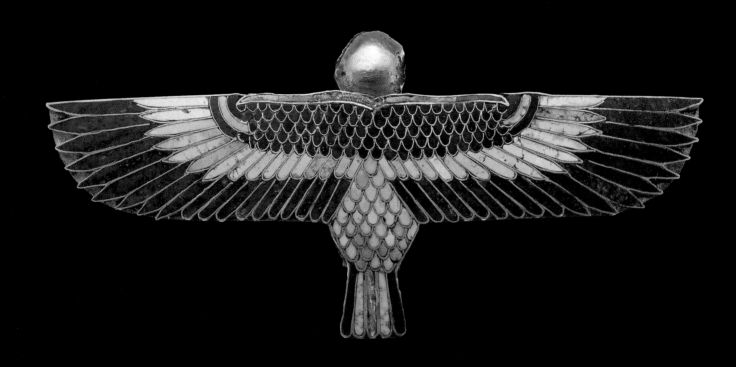

(Fig. 38) *Amulet of ba-bird.* Saqqara. Ptolemaic Period, 305–30 B.C. Gold, lapis lazuli, turquoise, steatite. 3.1 x 6.8 x 0.9 cm
(1¹⁄₄ x 2⁵⁄₈ x ³⁄₈ in.). Collection of the Brooklyn Museum of Art. Charles Edwin Wilbour Fund. 37.804E.

(Fig. 39) *Palette with two birds.* Edfu. Predynastic Period, late Naqada II Period–Naqada III Period, c. 3400–3000 B.C. Slate. 22.5 x 11.8 x 0.7 cm (8⅞ x 4⅝ x ⅜ in.). Collection of the Brooklyn Museum of Art. Charles Edwin Wilbour Fund. 09.889.161.

(Fig. 40) *Bowl with white lines.* Naga el-Deir, cemetery 7000, tomb 36. Predynastic Period, Naqada I Period, c. 3850–3650 B.C. Terracotta, painted. 8 x 15.9 x 15.9 cm (3 x 6¼ x 6¼ in.). Collection of the Phoebe Apperson Hearst Museum of Anthropology, University of California, Berkeley. 6-4735.

THE GEOGRAPHIC SETTING

Now that we know the types of art the Egyptians produced, we can focus on the qualities that distinguish Egyptian art from all other creative expression. The short answer is that Egyptian art is merely one, highly complex facet of a unique religious system. Like many early belief systems, Egyptian religion both reflected and drew inspiration from the geographic setting in which it flourished. To understand Egyptian art and religion, we must learn about the natural setting.[18]

When the fifth-century B.C. Greek historian Herodotus called Egypt "the gift of the Nile," he reduced to convenient aphorism the self-evident basis of ancient Egyptian civilization.[19] The Nile River was the physical and psychological focus for all human life in Egypt. It is formed from two smaller courses: the White Nile, which emerges from Lake Victoria, and the Blue Nile, originating in the Ethiopian highlands. The two merge at Atbara in the modern Arab Republic of the Sudan and flow, as the Nile River, northward across the Sudanese-Egyptian border to the city of Aswan. At Aswan, the First Cataract, an expanse of massive granite boulders and impassable rapids that served as ancient Egypt's southern boundary, obstructs the current. Here, all river traffic had to transfer to overland caravans, bypassing the cataract's swirling waters. Once clear of this formidable barrier, the Nile resumes its languid northerly flow for approximately four hundred miles until it reaches a point just north of Memphis, Egypt's ancient capital. A narrow ribbon of cultivated land flanks the river from Aswan to Memphis, as it did in antiquity. We call this area Upper Egypt (Fig. 43); to the ancient Egyptians it was *Shemau*. Just past Memphis, the river separates into several branches—seven in antiquity, and two today—that flow northward through a broad delta extending to the

(Fig. 43) Upper Egypt, looking across the Nile toward the west bank of the river at the modern city of Luxor.

(Fig. 44) Lower Egypt, looking across a field at the site of Mendes in the northeast Delta.

Mediterranean Sea. This expanse of rich alluvial soil, among the world's most fertile, makes up Lower Egypt (Fig. 44). The ancient population knew this area as *Ta-meheu*.

Together, *Shemau* and *Ta-meheu* formed *Ta·wy* ("the Two Lands," a political designation), or, alternatively, *Kemet* ("the Black Land," an allusion to the characteristic color of Egyptian soil). *Kemet* marked the extent of the ordered universe and all civilized life. Beyond *Kemet* was *Deshret* ("the Red Land"), the sterile deserts and mountains flanking the Nile Valley. In this region, life was harsh and forbidding, strange people spoke

incomprehensible languages, and existence knew no order. Both *Kemet* and *Deshret* were surrounded, or so the Egyptians believed, by Nun, a primordial ocean of dark, inert waters symbolizing chaos.

The Nile's influence on the Egyptians' thought processes and worldview cannot be overstated. Every spring, driving rains and melting snow in the Ethiopian highlands swelled the Blue Nile; by midsummer these waters reached Egypt.[20] From July to October, the Nile overflowed its banks, inundating millions of acres of farmland. The floodwaters eventually receded, leaving vast deposits of new alluvial soil on the fields flanking the river. Appreciative farmers plowed and seeded this rich dark soil, confidently anticipating that the early spring harvest would yield sufficient grain, fruit, and vegetables to feed the entire population. This rhythmic cycle—flood, recession, flood, recession—continued through the millennia. Some years, the flood might be either too high, causing damage to the fields, or too low, resulting in drought. These aberrations, however, were simply variations on an unchanging theme. The Egyptians came to view the Nile's annual cycle as a given, as *the* great natural cycle ensuring their existence throughout time.

Responding to the model of the unfailing Nilotic cycle, they came to see life as a predictable consequence of nature's cyclical patterns. The rising, setting, and (re-)rising of the sun guaranteed light and warmth each day; the sowing, cultivation, and harvesting of plants produced seeds for the next planting season; the monthly lunar cycle proclaimed the restoration of wholeness; even the return of migratory birds was a metaphor for rebirth. The cyclical model also governed how the Egyptians understood and recorded time. They recognized linear time, the stringing together of events in chronological order, much as we do today. But they experienced life in the context of cyclical time, the necessary repetition of occurrences.

The Egyptians' view of universal creation (cosmogony) followed the model of eternal natural cycles.[21] All existence began at the First Moment, when a mound of earth emerged from the lifeless waters of Nun. (We can recognize the inspiration for this looming, elemental imagery in the first mound of new alluvial soil that rose from the receding Nile waters each autumn.) The sun, in its role of Creator, stood atop this hillock and fashioned four deities, two brothers and two sisters, who comprised all being: Geb, the earth god; Shu, god of the air; Nut, the mistress of the sky; and Tefnut, goddess of moisture. Although the details of the story varied over time and from place to place, fundamental elements were invariable. To prevent Nut (sky) and Geb (earth) from enjoying eternal sexual union, the Creator placed Shu (air) between them. The image of Nut as a great celestial cow, her body covered with stars, standing above the prostrate Geb while Shu raises his arms to separate them became an icon for the Egyptians' view of their universe.

The Creator also established *ma'at,* a governing principle that defined universal order and perpetuated the great natural cycles. As long as the dictates of *ma'at* were followed, all existence was safe, but any serious deviation threatened to plunge the universe back into the dark nothingness of Nun (chaos). *Ma'at* imposed strict obligations on all people. For example, rules of social decorum—deference to superiors, respect for parents, charity for widows and orphans—not only dictated normative behavior but were mandated by *ma'at* and *had* to be respected. Crucial to the concept of *ma'at* was the notion that the First Moment was not a one-time event; it was cyclical and had to be re-created every day. Only divine power could reproduce the First Moment. To ensure that the gods would re-create *ma'at,* mortals were required to worship them, adorn their statues, and perform their rituals every day. Otherwise, the daily renewal of Creation, and thus all existence, would cease.

(Fig. 45) *Statuette of Isis suckling Horus.* Provenance not known. Late Period, Dynasty 26–31, 664–332 B.C. Bronze. 33 x 11 x 16.5 cm (13 x 4⅜ x 6½ in.). Collection of The Walters Art Museum, Baltimore. 54.2021.

The first serious threat to *ma'at* occurred when the second generation of gods, the divine children of Geb and Nut, came into conflict.[22] The eldest son, the god Osiris (Fig. 17), ruled as king of Egypt with his sister-wife, the goddess Isis, as queen (Fig. 45). Osiris epitomized the ideal of the wise and beneficent ruler. He taught his subjects to grow crops, erect buildings, and live in harmony according to the protocols of *ma'at.* In time, Osiris's ruthless brother Seth grew jealous of his power. Seth murdered Osiris, dismembered the

Thoth, the god of wisdom who was depicted as a baboon or an ibis-headed man, rescued the eye of Horus and restored it to the falcon. The Egyptians considered this eye to be the moon. The other gods were eventually forced to intercede, and a tribunal was summoned, with Geb serving as chief judge. Before his fellow gods, Seth proclaimed that as Osiris's eldest brother, he was the rightful king of Egypt, while Horus argued that he should be proclaimed ruler because he was Osiris's son and thus the legitimate heir. The gods declared that Seth's actions ran counter to *ma'at*. Horus would rule Egypt for all time; Osiris, because he had died, became Lord of the Underworld; and Seth was banished forever from the civilized world.[23]

This resolution established the theoretical model for kingship. The king (pharaoh) was the earthly manifestation of Horus, one of the major deities of the ancient pantheon. Official dogma recognized kings as gods—a few of the most presumptuous even insisted on being worshiped—and elements of costume and regalia surrounded rulers with an aura of divine otherness. The depiction of pharaoh as a sphinx, a creature with a human head and lion's body (Fig. 20), stressed the king's supernatural powers. Standard inscriptions referred to kings as the "good [or perfect] god" or the "son of the sun[-god]." Yet, can we believe than most Egyptians truly accepted their rulers as omnipotent and immortal? Presumably, they recognized that the man (or, on rare occasions, woman) sitting on the throne might well display physical, mental, and emotional weaknesses.[24] The ancients resolved the apparent incongruity of a "divine" monarch with conspicuous human frailties by positing that the *ka*, or spiritual essence, of kingship temporarily resided within the physical reality of the person occupying the position of king. The royal *ka*, not the ruler's body, was immortal. The royal *ka* passed from one ruler to the next just as the divine tribunal had transferred the right to rule from Osiris to Horus. The physical form of the king inevitably changed over time, but the principle defining "king" was indestructible.

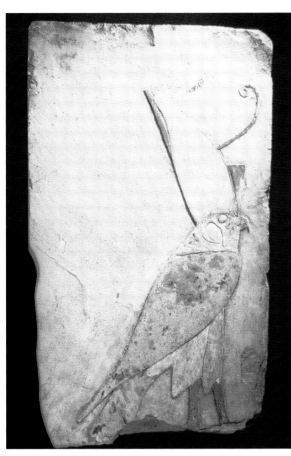

(Fig. 46) *Relief of Horus falcon.* Deir el-Bahri. Middle Kingdom, Dynasty II, reign of Mentuhotep II (c. 2008–1957 B.C.). Limestone, painted. 48 x 28.6 x 16 cm (18⅞ x 11¼ x 6¼ in.). Collection of the Carnegie Museum of Natural History, Pittsburgh. Egypt Exploration Fund, 1907. 3076-2.

god-king's body, scattered the pieces throughout Egypt, and usurped his brother's throne. Isis, aided by her sister, and Seth's wife, Nephthys, set out to recover the bits of her husband's corpse and restore him to life. Only then could Isis and Osiris conceive a child who could avenge Osiris's murder and reclaim the throne. Once she and Nephthys had collected Osiris's physical remains, Isis used her magic to restore him to life and join in sexual embrace. The product of their union was the sky god Horus, traditionally depicted as a majestic falcon (Fig. 46). Isis and the infant Horus hid from Seth's murderous henchmen in the Lower Egyptian swamps until the child was old enough to confront his uncle and restore the legitimacy of Egyptian kingship. When they met, a gruesome battle ensued. Horus ripped off one of his uncle's testicles, and Seth tore out Horus's left eye, casting it over the edge of the earth.

ART AND RELIGION: FORM

The Creation myth, the establishment of *ma'at*, and the conflict of Horus and Seth were not merely curious tales recounted to entertain. Their inherent truths rest at the heart of nearly every aspect of ancient Egyptian life. Not surprisingly, the singularities of Egyptian religion determined the characteristics of Egyptian art that make it unique and recognizable. Statues, reliefs, and paintings were, at the most elemental level, religious objects, operating in a sacred sphere. They look the way they do because of where and how they were used.

For the Egyptians, mere knowledge of the Creation myth was not enough. They had to live it as well, and art was crucial to the process.[25] Temple statues, for example, functioned in cultic rituals celebrated to appease the gods, encouraging the daily re-creation of Creation. Cult statues, images of divinities, stood in the sanctuary, the most secluded, sacrosanct chamber in the temple. Usually fashioned in gold or silver, cult statues were frequently melted down by later generations of Egyptians; only a handful survive. Far more common are stone images of gods originally positioned throughout the temple as the focus of worship for those denied access to the sanctuary. Beginning in the Late Period (664–332 B.C.), the faithful left *ex-votos*, small images of gods meant to remind the deities of the donor's devotion (Fig. 45). Not all temple sculpture represented divinities; some depicted high-ranking officials. If a nobleman made an endowment to a temple or simply donated a statue of a god, he might commemorate his generosity with another statue, conspicuously displayed in the temple precinct, symbolizing the gift (Fig. 17). Starting in the New Kingdom (c. 1539–1075 B.C.), officials set up statues of themselves in public places throughout the temple so that they might watch, as members of an eternal audience, the never-ending performance of sacred rites and ceremonies (Fig. 47).

The placement of royal statues in temples also spoke to the need for celebrating daily rituals. Theoretically, pharaoh served as titular high priest of every Egyptian cult, and his participation was required at *every* temple, *every* day to ensure the gods' appeasement and the maintenance of *ma'at*. Of course, this ideal was impossible to realize, so statues and relief representations functioned as magical substitutes for the king. One way to secure a royal presence was by constructing a *ka*-chapel, complete with a sculpture of pharaoh, within the temple precinct. The royal *ka*, the essence of kingship, would dwell within the statue and thereby guarantee that the royal spirit, if not the king's body, presided over the daily ceremonies. Other royal images commemorated the achievements of long-dead monarchs. In the temple of the goddess Hathor at Dendera, for example, the Sixth Dynasty ruler Pepy I, manifest in an alabaster statuette (Fig. 48), was revered for more than two thousand years. Some rulers took the notion of divine kingship to a literal extreme, declaring themselves gods who required worship during their lifetimes. These kings erected statues of themselves in cult temples where the faithful could pray and leave appropriate offerings. Sculptures also stood in funerary temples, large structures built near the king's tomb. During the burial ceremony, these statues substituted for pharaoh's lifeless body and functioned as "props" in complex rituals performed by teams of highly trained mortuary priests. In one of the most crucial, the "Opening of the Mouth" ceremony, the officiating priest placed a primitive adz in front of the sculpture's mouth to activate the figure and thus reinvigorate the deceased ruler. This rite enabled him to consume the food and drink left as offerings.

Along with temples, tombs were the other major repositories for ancient Egyptian statuary.[26] Like temple sculpture, tomb figures had specific religious functions; they were sophisticated pieces of funerary equipment intended to facilitate the

(Fig. 47) *Block statue of Djed-Khonsu-iuf-ankh.* Provenance not known. Third Intermediate Period, Dynasty 22–25, c. 945–656 B.C. Gabbro. 31.1 x 17.5 x 21.3 cm (12 1/4 x 6 7/8 x 8 3/8 in.). Collection of The Metropolitan Museum of Art. Rogers Fund, 1907. 07.228.27.

(Fig. 48) *Statuette of King Pepy I*. Probably from Dendera.
Old Kingdom, Dynasty 6, reign of Pepy I (c. 2338–2298 B.C.).
Egyptian alabaster. 26.5 x 6.6 x 15.7 cm (10^7/$_{16}$ x 2^9/$_{16}$ x 6^3/$_{16}$ in.).
Collection of the Brooklyn Museum of Art. Charles Edwin Wilbour
Fund. 39.120. This object is not in the exhibition.

ence physical resurrection. For king and com-
moner alike, this hope came with a significant
condition attached: in order to achieve immor-
tality, the deceased's *ka* had to be favored by the
daily presentation of offerings and recitation of
prayers in the tomb. Even if these rituals were dili-
gently observed, the *ka* could endure only if it had
an eternal abode to which it could return periodi-
cally. The most permanent type of resting place
was the tomb, ranging in scale from a monumen-
tal building to a simple hole dug out of the desert
floor. Just as Osiris ruled in the underworld, mor-
tals began their quest for eternity underground.

Mummies served as another, more immediate
kind of dwelling, but quite early in their history
the Egyptians realized that mummies were vul-
nerable to damage from scavengers, floods, or
collapse of the tomb. By the Third Dynasty
(c. 2675–2625 B.C.), artists had created a type of
semi-permanent "spare body" for the *ka*. Usually
crafted of stone or wood, these "spares" are what
we call statues. The *ka*-statue was thus the most
common type of private tomb sculpture (Fig. 49).
It not only provided the spirit with a place of
safety and comfort, but it was also the primary
receptor of offerings. Yet for part of Egyptian his-
tory, visitors to the tomb who desired to leave
funerary gifts for the deceased never saw the
mummy or the *ka*-statue. The subterranean burial
chamber of an Old Kingdom tomb was generally
accessible only by a deep vertical shaft cut into
the bedrock. Once the shaft was sealed, people
bearing gifts—food, drink, prayers—had to focus
their generosity on a so-called false door, an
inscribed slab of immovable stone that resembled
a functioning door, located on the west wall of
the tomb's offering chamber (Fig. 50). The actual
ka-statue stood in a *serdab*, a small room located
immediately behind the false door. It was literally
walled away, inaccessible to and unseen by those
entering the tomb. The tendency to conceal the
ka-statue gradually fell out of favor. By the
Middle Kingdom, architects had replaced the
traditional *serdab* with a niche or shrine stand-
ing in a tomb chapel and housing a statue visible
to any visitor.

deceased's quest for rebirth and everlasting life.
The essential purpose of religion is to help the
believer deal with the spiritual and psychological
fear of death. Egyptian religion did it better than
most. The tale of Osiris established the crucial,
comforting principle that mortals could experi-

such as wrestling, throwing a discus, or brandishing a sword and in reflective moments, like resting following a boxing match or collapsing in exhaustion after sex. In contrast, Egyptian artists generally restricted themselves to a very limited number of static poses, including sitting, squatting, kneeling, or standing with the left leg forward. This artistic choice was not predicated on a lack of ability; sculptors were capable of showing figures in motion (Fig. 19). Rather, they aimed to create images that would be eternally valid. Motion or rest are evanescent states and, in the context of limitless time, insignificant. If a figure was to have everlasting validity—as the focus of cyclical worship, as a member of an eternal audience, or as the recipient of continual gifts—it could not assume a transitory pose. A Classical bronze representing Zeus hurling a thunderbolt depicts a moment in time; Egyptian statuary

(Fig. 49) *Statue of Inteska*. Giza, cemetery 1000, tomb 39. Old Kingdom, late Dynasty 5 or early Dynasty 6, c. 2400–2300 B.C. Limestone, painted. 50.8 x 14 x 21.1 cm (20 x 5$\frac{1}{2}$ x 8$\frac{1}{4}$ in.). Collection of the Phoebe Apperson Hearst Museum of Anthropology, University of California, Berkeley. 6-19800.

The cultic and funerary functions of ancient Egyptian statues profoundly influenced their appearance (Fig. 51). One of the most conspicuous characteristics of Egyptian three-dimensional art, for example, is the absence of any suggestion of motion or transitory existence. Greek sculptors excelled at capturing subjects in spirited actions

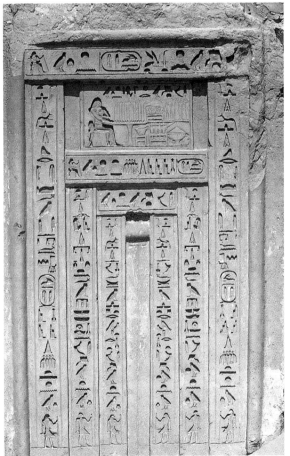

(Fig. 50) False door from the tomb of Khenu at Saqqara. Dynasty 5.

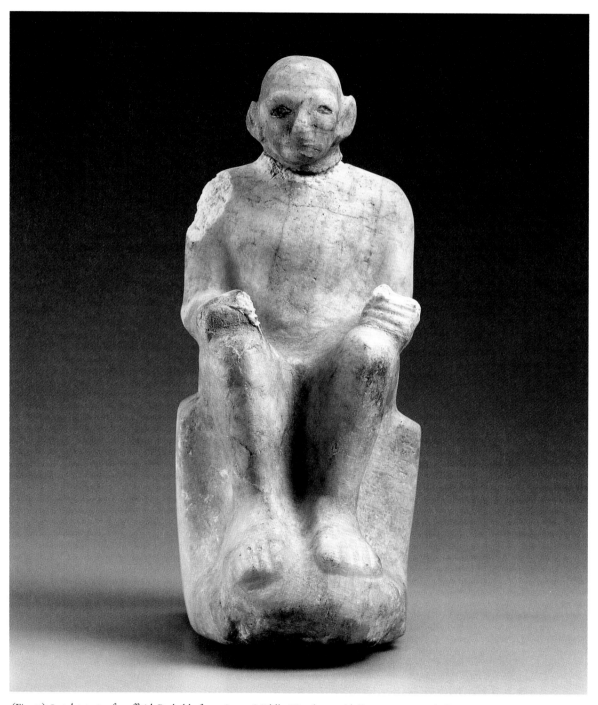

(Fig. 51) *Seated statuette of an official*. Probably from Asyut. Middle Kingdom, mid-Dynasty 11 or early Dynasty 12, c. 2008–1900 B.C. Egyptian alabaster. 28 x 12.5 x 19.5 cm (11 x 4$^{15}/_{16}$ x 7$^{11}/_{16}$ in.). Collection of the Museum of Fine Arts, Boston. Gift of William Kelly Simpson in memory of William Stevenson Smith. 1971.20.

expresses timelessness. One might say that Greek sculpture is to sports photography what Egyptian sculpture is to portrait painting.

Egyptian sculpture's strict reliance on frontality can also be traced to the religious functions of art. Nearly all Egyptian statues stare straight ahead. Even the figure of a mother holding her child shows the woman directing her attention forward instead of toward the infant (Fig. 45). For modern audiences, this convention gives the best Egyptian sculpture a sense of immediacy as the figures seem to stare directly into the viewer's eyes. Try staring into a statue's eyes—the effect

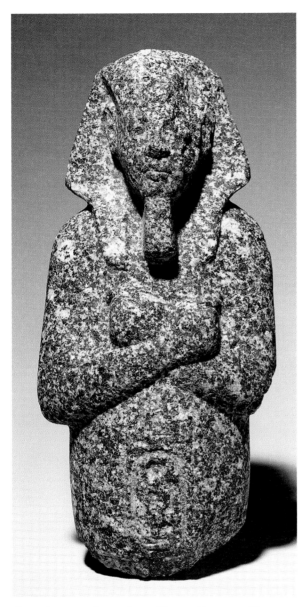

(Fig. 52) *Funerary figurine of King Akhenaten*. El Amarna. New Kingdom, Dynasty 18, Amarna Period, reign of Akhenaten (c. 1353–1336 B.C.). Granite. 18.3 x 8.4 x 5 cm (7³⁄₁₆ x 3⁵⁄₁₆ x 1¹⁵⁄₁₆ in.). Collection of the Brooklyn Museum of Art. Charles Edwin Wilbour Fund. 35.1870.

can be hypnotic. But this connection is incidental. Frontality was meant for the statue's benefit, not the onlooker's. Temple sculpture, particularly cult images, stood in shrines, where they received offerings presented by cult priests; they looked ahead to identify the donor and the donation. If they turned their heads even slightly, the sides of the shrine would obscure their view, and acts of piety and generosity could not be acknowledged. Likewise, Old Kingdom tomb effigies sealed away in the *serdab* constantly confronted the back of

the false door as if to see magically through the stone slab and recognize their benefactors.

Two unusual statue types represented here offer additional testimony about the close relationship between sculptural form and funerary beliefs. The first are so-called serving statues (Fig. 19). Recent scholarly research suggests that Egyptian artists made these stone figures for only a short period of time, from late Dynasty 4 to mid-Dynasty 5.²⁷ Most Egyptian statuary reproduces the human form in static poses, with little or no hint of the individual's societal role. Serving statues, however, show considerable action and emphatically proclaim the subject's occupation. Cooking over a low fire, grinding grain, turning a pot on a wheel, and slaughtering a bound ox are among the activities depicted. These statues may represent the tomb owner's estate staff, charged with serving him in the afterlife, or they could be family members of the deceased shown fulfilling their obligation to supply their relative's eternal sustenance. Unlike most tomb statuary, which caught its subject in an eternally valid pose, serving statues represented figures busily performing those very tasks that would enable the tomb owner to be reborn and live forever.

The Egyptian name for the second class of anomalous sculptures changed over time (Figs. 52, 53). In Dynasty 18 (c. 1539–1292 B.C.), they were called *shabtis*; for Egyptians of the Nineteenth Dynasty (c. 1292–1190 B.C.), they were *shawabtis*; *ushebtis* was the term of choice in Dynasty 21 (c. 1075–945 B.C.) and remained the common designation for the next thousand years. Today, Egyptologists prefer the general term "funerary figurines." Most examples show their subjects standing with legs held closely together and bodies shrouded in tight-fitting cloaks that give them the appearance of miniature mummies. Although connoisseurs and collectors often covet funerary figurines as attractive works of art, in antiquity their importance derived solely from their function as standard pieces of burial equipment. If the gods required the deceased to perform agricultural tasks in the afterlife, he or she

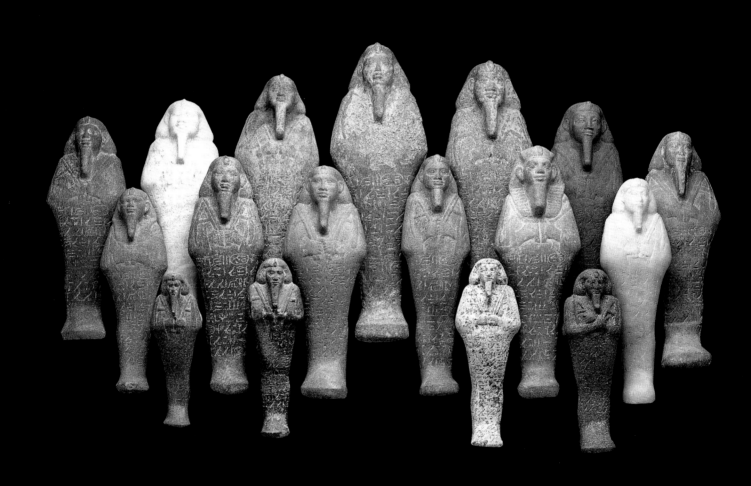

(Fig. 53) *Funerary figurine of King Taharqo* (middle row, third from left). Nuri, pyramid I (Taharqo). Third Intermediate Period, Dynasty 25, reign of Taharqo (c. 690–654 B.C.). Granite. 34 x 12.5 x 8.5 cm (13⅜ x 4¹⁵/₁₆ x 3⅜ in.). Collection of the Museum of Fine Arts, Boston. Harvard University–Museum of Fine Arts Expedition. 21.2959.

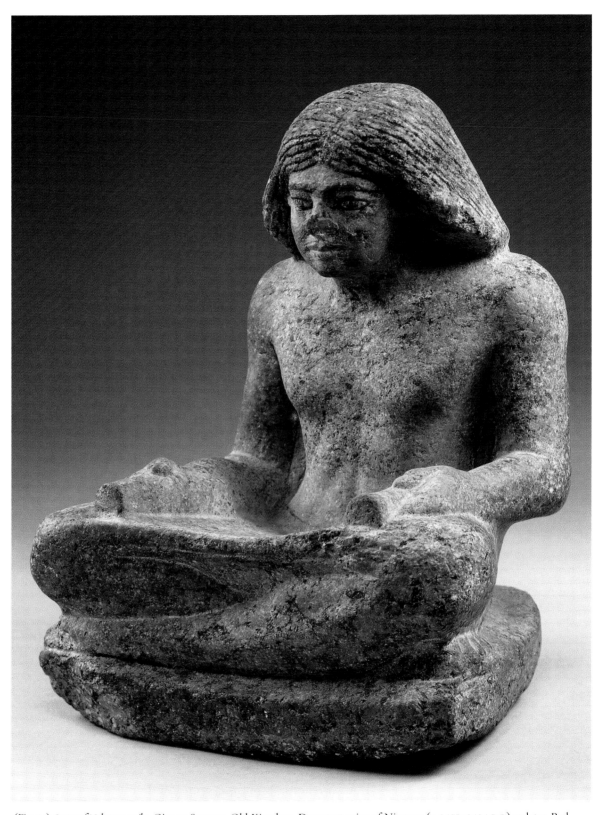

(Fig. 54) *Statue of Nykare as scribe.* Giza or Saqqara. Old Kingdom, Dynasty 5, reign of Niuserre (c. 2455–2424 B.C.) or later. Red granite, painted. 30.5 x 24.2 x 22.2 cm (12 x 9¹⁄₂ x 8³⁄₄ in.). Collection of The Metropolitan Museum of Art. Rogers Fund, 1948. 48.67.

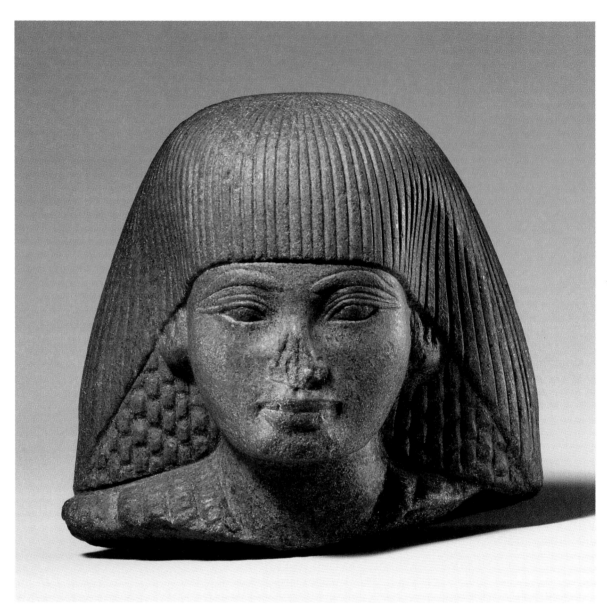

(Fig. 55) *Head of a nobleman.* Provenance not known. New Kingdom, Dynasty 18, reign of Amunhotep III (c. 1390–1353 B.C.). Graywacke. 10.2 x 10.5 x 7.6 cm (4 x 4⅛ x 3 in.). Collection of The Metropolitan Museum of Art. Purchase, Fletcher Fund, and the Guide Foundation, Inc. Gift, 1966. 66.99.31.

would turn to the funerary figurines, which could serve as magical substitutes. According to a spell inscribed on many examples, they would "cultivate the fields...irrigate the [river]banks...[and] transport sand from the east to the west," freeing the deceased to enjoy an eternity of tranquility and repose. An Egyptian of means might be buried with 360 funerary figurines—one for each workday in the year—and thirty-six overseer statuettes, each responsible for a gang of ten.

One quality of Egyptian sculpture familiar to any museum visitor is the frequent damage inflicted on noses (Figs. 16, 54–58). Since the nineteenth century, archaeologists have unearthed thousands of sculptures with smashed or broken noses; to this day, Egyptologists find mutilated statues in sealed tombs that have been undisturbed for millennia. Clearly, the breakage occurred in antiquity. Some instances can be explained quite simply: when a statue falls forward, the nose is the first point to hit the ground. Not every example of damage, however, is accidental. Many statues

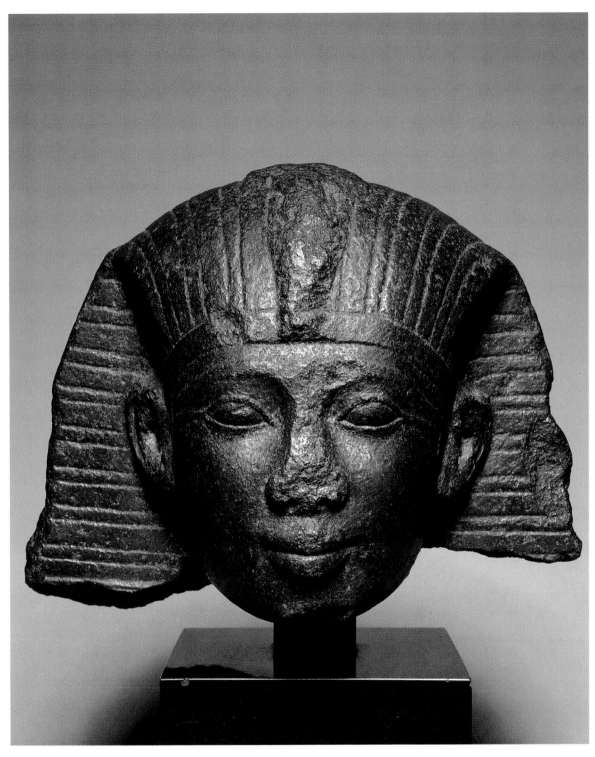

(Fig. 56) *Head of a king in nemes-headdress.* Provenance not known. Third Intermediate Period, Dynasty 21 or 22, c. 1075–712 B.C. Granodiorite. 27.5 x 35 x 28.4 cm (10⅞ x 13¾ x 11⅛ in.). Collection of The Cleveland Museum of Art. Gift of John Huntington Art and Polytechnic Trust, 1914. 1914.663.

show evidence of deliberate mutilation with hammer and chisel. These acts of vandalism reflect sculpture's religious role. The "Opening of the Mouth" ceremony enabled a statue to receive offerings by magically transforming it into a type of living or animate being, whereas smashing the nose effectively "killed" it, depriving the deceased of an afterlife. Tomb robbers were particularly

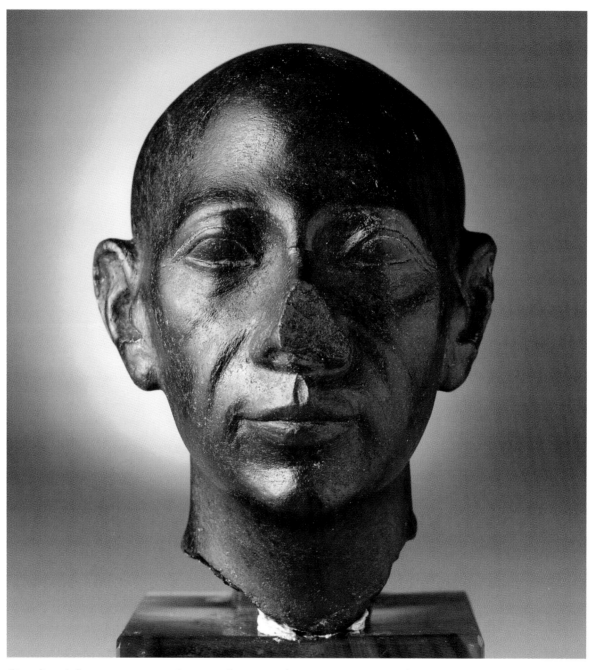

(Fig. 57) *Head of a man.* Provenance not known. Ptolemaic Period, c. 200–150 B.C. Graywacke. 8.7 x 6.5 x 8.8 cm (3^7/$_{16}$ x 2^1/$_2$ x 3^1/$_2$ in.). Collection of The Detroit Institute of Arts. City of Detroit Purchase. 40.48.

ardent practitioners of nose smashing, especially if they were at all superstitious or religious. A tomb owner whose soul was destroyed would have no way of exacting revenge on the despoilers of the tomb, so breaking the nose could represent an attempt to escape punishment. Alternatively, Egyptian law punished certain crimes, such as perjury and temple robbery, by cutting off the culprit's nose. Perhaps some of the damaged stat-

ues belonged to individuals whose misdeeds were discovered, and punished, after they had been buried.[28]

Most aspects of what we've discussed so far—poses, frontality, lack of motion—relate to a statue's essential shape or form. Egyptian sculptors did not enjoy a wide range of choices in form when designing a work of art. Occasionally they

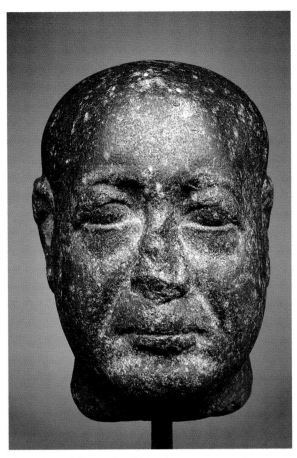

(Fig. 58) *Head of man with stubble beard.* Provenance not known. Early Ptolemaic Period, 3rd century B.C. Granodiorite. 10 x 7 x 10 cm (3⅞ x 2¾ x 3⅞ in.). Collection of the Museum of Fine Arts, Boston. Martha A. Willcomb Fund. 50.3427.

might add a new sculptural form to the list of possible options, such as the so-called block statue (Fig. 47), which appeared in the Middle Kingdom, but formal innovations were always rare. To the modern mind, the reluctance of ancient Egyptians to embrace new forms might make them susceptible to the charge of being "conservative." Yet this characterization serves only to demonstrate how far removed we are from their world. Certainly, were we to judge the creations of ancient craftsmen against the rate of change in, say, contemporary art or automotive design, the Egyptians would look tradition bound. Yet, as we have seen, the Egyptian of antiquity was producing objects to function in a religious context, unlike his modern, often commercially driven counterpart. If a sculptural form worked effectively in relation to cultic or funerary beliefs, there was no need to alter it. Similarly,

unless a new set of beliefs arose that might inspire a fresh sculptural form, like the block statue, artists would feel no need to innovate. So was ancient Egyptian art conservative? In its formal qualities, yes. But in other, non-formal aspects, artists could be surprisingly open to change.

ART AND RELIGION: STYLE

The Egyptians' treatment of style, the distinctive features of artistic expression characterizing a period or an individual artist, was perhaps the most variable and changeable aspect of the visual arts.[29] Throughout their history, Egyptian artists embraced numerous styles ranging from idealizing (Fig. 49), to stylized (Fig. 55), naturalistic (Fig. 59), and exaggerated (Fig. 58). Styles could differ from one dynasty to the next (Figs. 54, 60); occasionally, two or more styles flourished in the same dynasty (Figs. 60, 61) or in the same reign (Figs. 62, 63). At any given moment, however, there was usually one dominant mode: the "court style" devised and executed by the Chief Royal Sculptor and his skilled assistants, who fashioned official images of pharaoh. Other artists, living both in the capital and in the provinces, followed the lead of these master carvers.

Styles changed for several reasons. A king's death might motivate court sculptors to introduce a different representational mode for the new monarch. If a Chief Royal Sculptor retired or died, his successor might wish to express his own aesthetic predilections. Evidence for such an occurrence seems to exist. During the Eighteenth Dynasty reign of Akhenaten, the Chief Royal Sculptor, Min, was succeeded by a man named Bek, whose tenure was concurrent with a shift in style from exaggerated (Fig. 28) to subdued. Even more subtle influences could come into play. Artists are by definition creative, and creative people chafe at uninspired reproduction. It is not difficult to imagine young artists reacting to the teachings of their masters and introducing discreet innovations that, over time, might coalesce into an entirely new style.

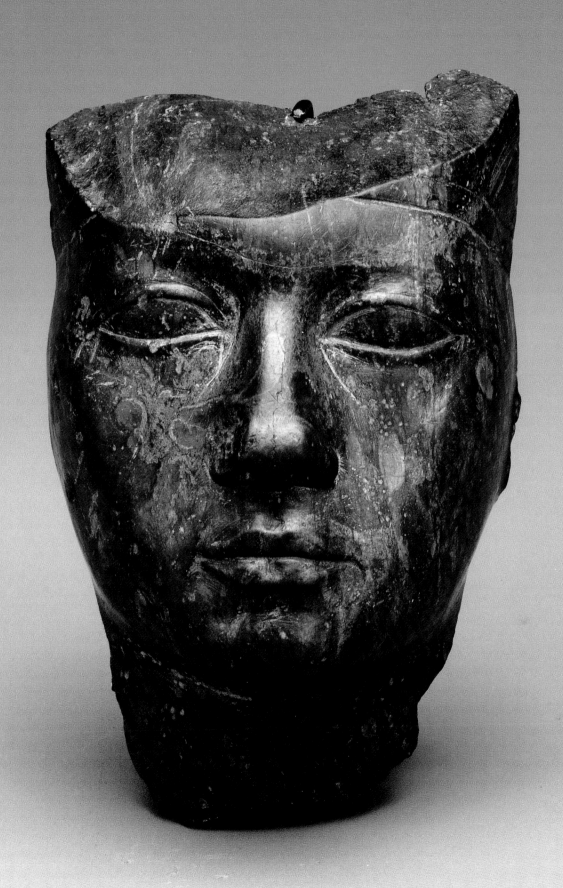

The Egyptians' interest in their own past also influenced artistic style. Ancient schools offered nothing comparable to a university history curriculum, but the Egyptians had ample opportunity to learn about their heritage. It was all around them. Not only could they visit the tombs and temples of bygone ages, but those who could read were well acquainted with the notables for whom these structures had been built. To cite one example, king Mentuhotep II (c. 2008–1957 B.C.), of Dynasty 11, buried his chief queen Neferu in an elaborately decorated tomb near his funerary temple at Deir el-Bahri. Some five centuries later, in Dynasty 18, Neferu's tomb became a "tourist attraction" for the ancient Egyptians. They visited her burial place and painted their names, as graffiti, on the walls. When Queen Hatshepsut (c. 1478–1458 B.C.), of Dynasty 18, decided to erect her own funerary temple next to Mentuhotep's, her architects realized that part of the new structure would block the entrance to Neferu's tomb. In deference to the earlier queen, Hatshepsut ordered her builders to construct a new passage into Neferu's burial place, enabling tourists to continue visiting it and allowing Hatshepsut to honor an ancient predecessor.

Such concern for the past sometimes led Egyptian artists to imitate earlier styles. Art historians call this conscious evocation of earlier periods "archaism." Archaism crops up occasionally in our own culture as well. In the late 1970s, for example, America pursued a dubious flirtation with the "good old days," characterized by a brief fascination with neo-rockabilly music (Stray Cats, Robert Gordon), faux leather jackets, polyester poodle skirts, and homogenized hoodlums (Arthur Fonzarelli, the Pink Ladies), all resurrected and transformed from 1950s popular culture. Egyptian attempts at archaism had ideological rather than nostalgic intent. The practice was most common at the beginning of a dynasty, when the founder of a new ruling house naturally wished to associate his dynasty with the cyclical

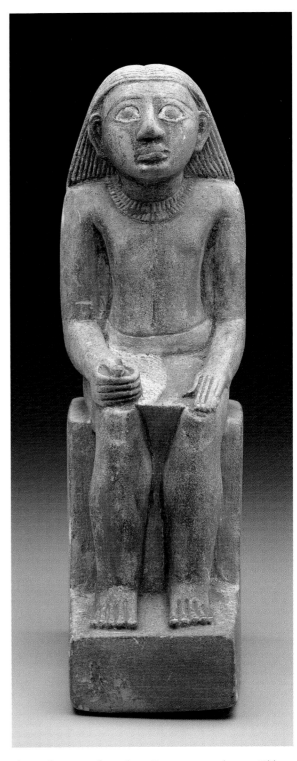

(Fig. 60) *Statuette of a seated man.* Provenance not known. Old Kingdom, Dynasty 6, c. 2350–2170 B.C. Limestone, painted. 28 x 9 x 15 cm (11 x 3⁹/₁₆ x 5⅞ in.). Collection of the Museum of Fine Arts, Boston. Sears Fund with additions. 04.1866.

(Fig. 59) *Head of Amenemhat III.* Provenance not known. Middle Kingdom, Dynasty 12, reign of Amenemhat III (c. 1818–1772 B.C.). Marble. 9 x 5.8 x 4.8 cm (3½ x 2¼ x 1⅞ in.). Collection of The Metropolitan Museum of Art. H. O. Havemeyer Collection. Bequest of Mrs. H. O. Havemeyer, 1929. 29.100.150.

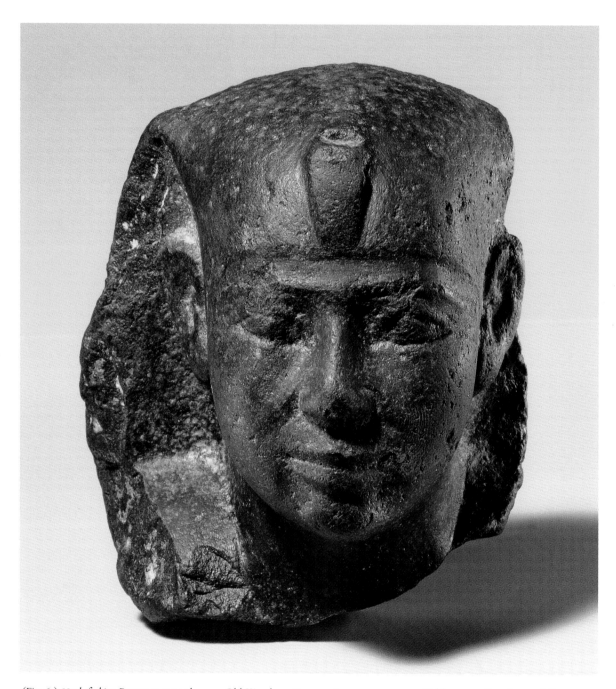

(Fig. 61) *Head of a king.* Provenance not known. Old Kingdom, Dynasty 6, c. 2350–2170 B.C. Gabbro. 9.5 x 8.3 x 8.9 cm (3³/₄ x 3¹/₄ x 3¹/₂ in.). Collection of The Metropolitan Museum of Art. Purchase, Fletcher Fund, and the Guide Foundation, Inc. Gift, 1966. 66.99.152.

nature of Egyptian history and specifically with an earlier period of prosperity and security. Artists studied the creations of such "classical" epochs and usually chose one as the model for their own sculpture and relief. Artists of the early Eighteenth Dynasty, for example, copied the works of early Dynasty 12, while royal sculptors of Dynasties 21 and 22 sought to emulate works produced during the reigns of the great Dynasty 18 pharaohs Thutmose III and Amunhotep II (c. 1472–1400 B.C.; Fig. 56). Some artists were so adept at emulating earlier styles that Egyptolo-

(Fig. 62) *Head of Queen Tiye.* Nubia, Dongola Province, probably Sedeinga. New Kingdom, Dynasty 18, reign of Amunhotep III (c. 1390–1353 B.C.). Peridotite. 20.3 x 11.5 x 12 cm (8 x 4¹/₂ x 4³/₄ in.). Collection of the Museum of Fine Arts, Boston. Gift of George A. Reisner. 21.2802.

70

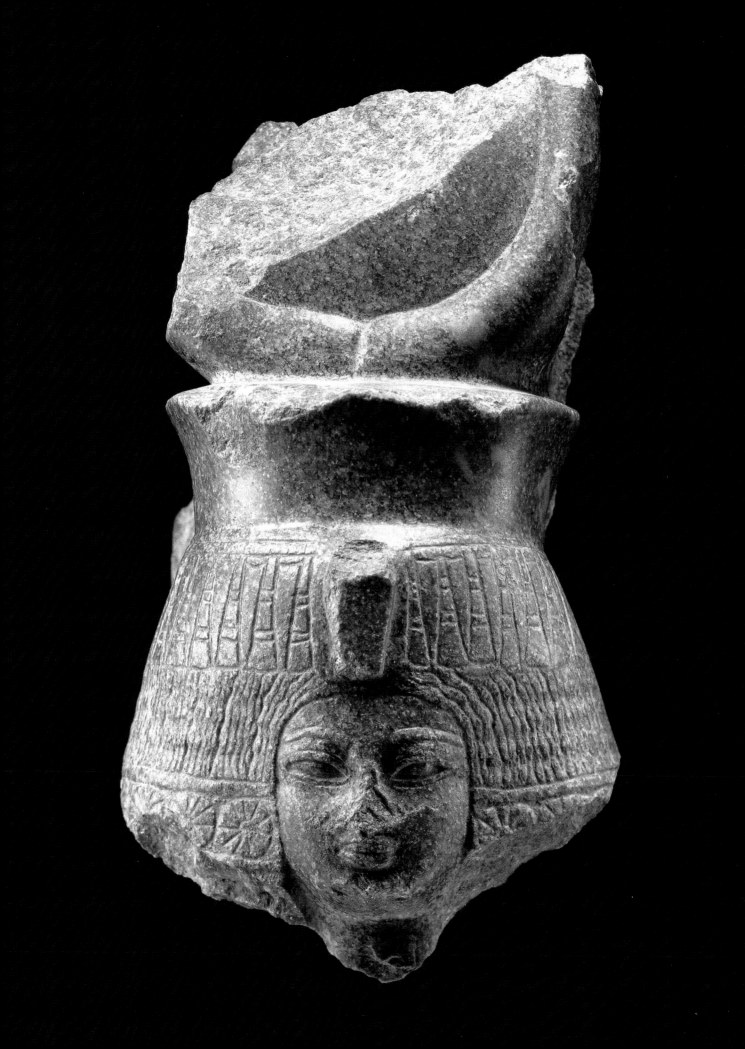

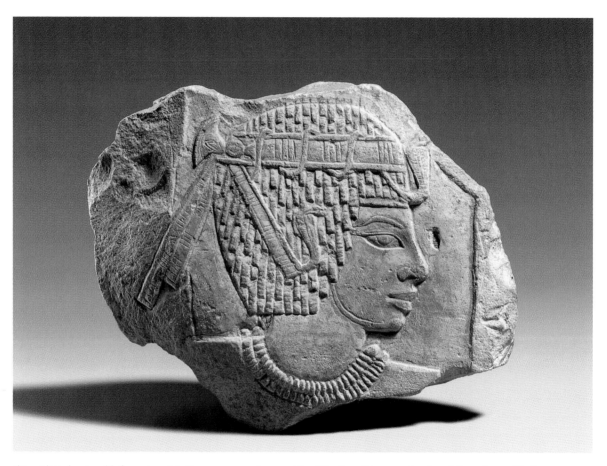

(Fig. 63) *Sculptor's model of Amunhotep III*. Provenance not known. New Kingdom, Dynasty 18, reign of Amunhotep III (c. 1390–1353 B.C.). Limestone. 8.5 x 10.8 x 3.2 cm (3⅜ x 4¼ x 1¼ in.). Collection of The Metropolitan Museum of Art. Theodore M. Davis Collection. Bequest of Theodore M. Davis, 1915. 30.8.83.

gists sometimes have difficulty distinguishing a later, archaizing piece from an older prototype.[30]

The myth of Horus and Osiris provides a clue to understanding another peculiarity of Egyptian stylistic expression: statues and reliefs of kings give little if any idea of what these rulers actually looked like. Pharaoh's body was only a temporary dwelling for the royal *ka*, so artists were concerned less with portraying the ruler's true physical appearance than with depicting him or her as a perfect, godlike being. For most of Egyptian history, artists showed their royal subjects with trim, athletic torsos and faces that conform to an idealized beauty (Fig. 63). We know from the mummy of the Eighteenth Dynasty pharaoh Amunhotep III (c. 1390–1353 B.C.), for example, that he was quite obese at the time of his death, yet official depictions show him in the full flower of athletic

manhood (Fig. 64). Only twice in Egypt's long history—circa 1800–1759 B.C. (roughly the last four decades of Dynasty 12) and during the Eighteenth Dynasty reign of Akhenaten (c. 1353–1336 B.C.)—were kings depicted as less than gods incarnate (Figs. 28, 52, 59).

The concept of divine kingship also influenced the Egyptian artist's depiction of non-royal subjects. Pharaoh's supreme position in the Egyptian social order meant that his face often replaced the faces of noblemen on their statues. Thus, the face of a nobleman from the Eighteenth Dynasty reign of Amunhotep III (Fig. 55) reproduces contemporary images of pharaoh (Fig. 63). The artist fashioned a version of the human form reflecting the prevailing concept of beauty, as defined by images of the king, and applied that version to depictions of non-royal members of society. Precisely why

(Fig. 64) Relief of King Amunhotep III in the Luxor Temple, Dynasty 18.

artists relied on royal models is impossible to say. The practice may have been political in nature: the official's desire to proclaim fealty to his monarch. Alternatively, it may have originated in the belief that the king's limitless powers could aid the nobleman in realizing life after death. Whatever the reason, the king's image generally served as the paradigm in most reigns. Even the faces of deities and queens (Fig. 62) imitated the royal countenance.

Occasionally, sculptors worked in a highly naturalistic or realistic mode suggesting true portraiture.[31] Sculptures of this type were particularly common in the Ptolemaic Period (305–30 B.C.; Figs. 57, 58). The question of whether the Egyptians fashioned true portraits continues to challenge art historians. If they did, can we assume that Egyptian artists learned the concept from their Greek contemporaries? Or did they

develop it independently? If not, how do we account for so many lifelike faces? Is it even valid to apply a modern definition of portraiture—an accurate depiction of reality that conveys something of the subject's personality—to an ancient artistic tradition that often stressed group identity over that of the individual? We'll probably always have to temper our responses with uncertainty. It is true that many Ptolemaic Period faces strike us as lifelike, and some even remind us of people we know. The thousands of surviving examples of Ptolemaic sculpture, however, fall into a restricted number of types (e.g., old bald men, fat men, etc.). Unless we assume that many Ptolemaic Egyptians looked alike, the similarity in sculpted faces may be due to artistic convention and might not represent an accurate depiction of the population. Portliness and jowls, for example, could have conveyed the notion of wealth rather than faithfully depicted the subject's obesity.

ART AND RELIGION: ICONOGRAPHY

We have seen that Egyptian religion informed the dynamics of artistic change. Style was protean, responding rapidly to a host of influences, mostly religious in nature; form, however, remained relatively static. New elements, like the block statue, could augment the artist's repertoire, but innovations necessarily emerged from some new aspect of belief or ritual. But how do we characterize iconography, the set of symbolic forms conveying the meaning of an image? Was it susceptible to innovation, or was it bound by tradition?

Egyptian art was rich in, or, one might say, overloaded with, symbols. The abundance of symbolic expression should not surprise us. As we have already seen, *the primal fear of any Egyptian was the possibility that chaos would overcome ma'at* and plunge existence into the primordial nothingness of chaos. Anthropologists tell us that societies cope with disorder by, among other methods, creating symbols with instantly recognizable, standardized meaning to all the members of the group.[32] Some of these symbols are active—such

as rituals and sacrifices—while others are explicitly visual, i.e., iconographic. If we accept this premise, then the Egyptians' pervasive worry about falling back into chaos necessarily predisposed them to a rich inventory of visual images.

An Egyptian might admire a work of art, but his or her first obligation was to understand or "decode" the many messages inherent in its appearance. When looking at a royal image, for example, the viewer had to internalize its intent. The headdress provided the first clue. The White Crown of Upper Egypt, which resembles a modern bowling pin, indicated that pharaoh was functioning as ruler of the south (Fig. 65). The Red Crown—think of a champagne bucket— symbolized dominion over Lower (northern) Egypt (Fig. 66). For representations of the king as ruler of the Two Lands, artists chose the Double Crown—a bowling pin inside a bucket (Fig. 46).

(Fig. 66) Relief of King Amunhotep II in a Red Crown in the temple of Amun at Karnak, Dynasty 18.

Scenes of coronation, combat, or the subjugation of chaos typically contained figures of pharaoh wearing the Blue Crown (Fig. 28). The *nemes*-headcloth was a generic wig-covering without specific geographic or ritual associations (Figs. 52, 56, 61). When a king sported a beard with a straight lower edge, he was emphasizing his humanity (Fig. 52); a curved beard communicated divinity. A menacing cobra frequently appeared on a royal headdress immediately above the king's forehead (Figs. 28, 52, 53, 61, 63). This serpent represents Wadjet, an ancient Lower Egyptian goddess charged with protecting the king's physical presence throughout eternity. Her presence, like that of a crown or a beard, informed the viewer that this was a *royal* image.

Private art had its own set of artistic conventions. Important officials carried staves and batons symbolizing their authority (Fig. 74); men wishing to immortalize their wisdom and education

(Fig. 65) Limestone head in a White Crown in the forecourt of the temple of Sety I at Abydos, Dynasty 19 (?).

74

(Fig. 67) *Head of a prince or priest of Ptah.* Provenance not known. New Kingdom, Dynasty 19, c. 1292–1190 B.C. Diorite. 20.6 x 17.8 x 20.6 cm (8⅛ x 7 x 8⅛ in.). Collection of The Metropolitan Museum of Art. Purchase, Fletcher Fund, and the Guide Foundation, Inc. Gift, 1966. 66.99.64.

appeared as scribes, seated cross-legged on the ground with a roll of papyrus in their laps (Fig. 54). Women also had iconographic elements specific to their roles. Priestesses of the goddess Hathor, for example, carried items associated with her cult, including a *sistrum* (an elaborate rattle) and a heavy necklace and counterweight (Fig. 33). Artists used three devices to convey the notion of "child": nakedness, the index finger held to the mouth, and a thick, braided sidelock extending from the crown of the head onto the shoulder. The sidelock had an additional application—it was worn by priests serving in the cult of the god Ptah (Fig. 67); no other priests were so adorned. Hand gestures sometimes communicated meaning as well. A figure bending the forearm to his or her chest expressed veneration (Fig. 22), while the attitude of extending the hands

(Fig. 68) Detail of relief from the tomb of Ay at El Amarna (tomb 25), Dynasty 18.

proclaimed humility before a more powerful be-
ing such as a king or god (Fig. 68). Colors could
express ideas. Light-colored skin, for example,
symbolized physical frailty. Thus, vital, active
men have reddish brown skin, while women and
the elderly often have pale complexions. In a
scene with two or more figures, relative size indi-
cated relative social rank, so in a relief of a man
confronting a deity, the god's image is larger.
For the same reason, in some family groups, the
father is taller than his wife and children, imply-
ing male dominance; in others, however, the fig-
ures appear on the same scale (Fig. 69), perhaps
connoting relative equality.

Tomb reliefs and paintings, like all the art we
have examined, spoke to the quest for eternal life,
but they spoke in many dialects and on many lev-
els.[33] An Egyptian tomb wall probably has more
obscure symbolic references than the last six verses
of "American Pie." We may interpret the daily-
life themes as a means of placing the spirit within
a familiar environment where it could feel at

home throughout eternity. A wealthy landowner
would find security surrounded by scenes he
knew well from life—idealized images of healthy,
contented farmhands planting and harvesting
grain, fishermen casting their nets into the Nile,
brewers making beer, workers leading herds of
cattle to slaughter (Fig. 70). Alternatively, the
Egyptians may have believed that these represen-
tations magically provided the tomb owner with
a permanent supply of food, drink, and furnish-
ings in the afterlife, and that representations of
food and drink heaped upon an offering table
also substituted for the real thing (Fig. 71). Both
interpretations are probably quite valid, but most
tomb scenes were also working on another, more
profound symbolic stratum.

If we analyze a single fragment from a Late
Period agricultural scene (Fig. 72), we can see
how this system of multiple meanings worked.
The vignette depicts the rear of a standing cow at
the precise moment she delivers a calf—note the
bit of afterbirth just below the newborn's eye. A

(Fig. 69) *Group statuette of a family.* Provenance not known. Middle Kingdom, late Dynasty 12–early Dynasty 13, c. 1800–1700 B.C. Granodiorite. 20.3 x 19 x 9.1 cm (8 x 7½ x 3⅝ in.). Collection of The Walters Art Museum, Baltimore. 22.311.

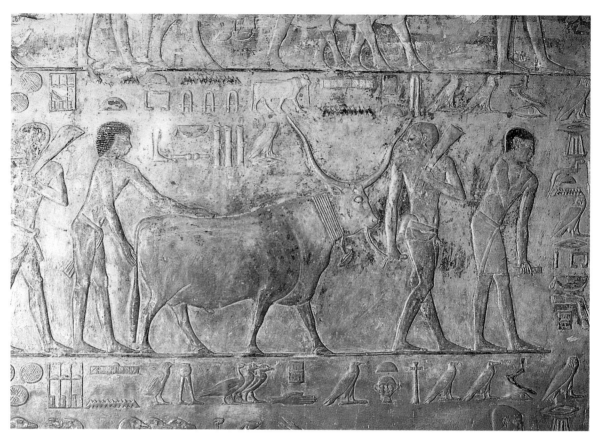

(Fig. 70) Detail of relief from the tomb of Ptahhotep at Saqqara, Dynasty 5.

farmhand, seen at the far right, assists in the delivery, carefully drawing the calf from the birth canal with a rope. Versions of this scene occur in many Old and Middle Kingdom tomb reliefs, strongly suggesting that the theme relates directly to crucial funerary beliefs. The events shown here certainly would have been commonplace in any agricultural society, and the calf's birth no doubt meant additional provisions. Seen on a purely symbolic level, however, the mother cow represents Nut, the ancient sky goddess who traditionally appears as a standing cow, and the calf stands for the sun, which is reborn from Nut's loins—the eastern horizon—each day at dawn. By introducing this most potent birth symbolism into his burial place, the tomb owner hoped to merge with the eternal solar cycle of birth-death-rebirth and, like the calf/sun, be reborn forever.

Or take the ubiquitous theme of the hippopotamus hunt (Fig. 73).[34] By Dynasty 18 (c. 1539–1292 B.C.), the scene had become a standard dec-

orative element in nobles' tombs. These illustrations show nobles stalking their prey while standing in a small reed skiff. They wear their finest linen and jewelry and often are accompanied by their wives and children, as if partaking in a joyous recreational jaunt. Certainly, the Egyptians had many reasons to hunt and eradicate hippos. They are extremely large and aggressive creatures and would have threatened normal river traffic, especially small boats or ferries. Despite their awkwardness out of the water, hippos are equally dangerous on land; adult males frequently sport razor-sharp, eighteen-inch tusks. These animals also have voracious appetites—an adult male can consume 150 pounds of grass a day. In a single night, a herd of twenty or more foraging animals could easily have consumed a farmer's crops for the entire year.

So it is hardly surprising that the Egyptians depicted hippo hunts in their tombs and temples. However, the story related by New Kingdom

(Fig. 71) *Relief of offerings for the deceased.* Provenance not known. Old Kingdom, Dynasty 5, c. 2500–2350 B.C. Limestone, painted. 48 x 38.5 x 3.8 cm (18⁷⁄₈ x 15³⁄₈ x 1¹⁄₂ in.). Collection of The Detroit Institute of Arts. Founders Society Purchase, Hill Memorial Fund. 76.5.

(Fig. 72) *Relief of man delivering calf.* Thebes, Asasif, tomb 34. Third Intermediate Period, late Dynasty 25, c. 670–656 B.C. Limestone. 14.2 x 17.8 x 2.6 cm (5⁹⁄₁₆ x 7 x 1⅛ in.). Collection of the Brooklyn Museum of Art. Charles Edwin Wilbour Fund. 55.3.2.

tomb scenes—a leisurely, family excursion into the marshes in a flimsy reed skiff—probably had little basis in fact. Drifting out into the middle of the Nile in a lightweight boat to harpoon a short-tempered creature roughly as large as a mid-size SUV (and equipped with two daggers projecting from the front bumper) was not a sportsman's dream. The solitary hunter ran the very real risk of being capsized and mauled. The Egyptians probably did hunt hippos, both on land and in the water, but the well-coordinated efforts of an entire team of expert hunters would have been necessary for safety and success. Women and children would have hindered the pursuit. So why do we have such a large number of scenes of carefree hunters and their families stalking hippos?

The answer is that this vignette, like so many

tomb scenes, must be interpreted on several levels—in this instance, the ideal and the mythological. New Kingdom paintings of hippo hunts depict the hunt as it *should* transpire in a perfect afterlife: the nobleman proclaiming his courage in the face of a most worthy and dangerous adversary. Never mind that the hunt didn't happen that way; reality was irrelevant. The tomb owner wanted an eternity of elegant and graceful kills. The tomb scene, then, idealized the hunt rather than depicted it. Also, Egyptian mythology associated the hippopotamus with Seth, sometimes as the embodiment of the usurper-god, sometimes as his henchman. By slaying a living hippo or simply showing himself in the tomb dispatching one with a harpoon, the nobleman was striving to overcome chaos by vanquishing the chief danger to *ma'at*.

80

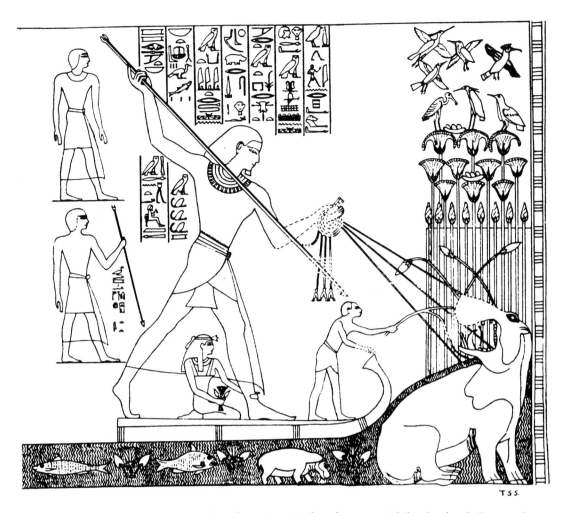

(Fig. 73) Line drawing showing a hippopotamus hunt from the tomb of Intef in western Thebes (tomb 155), Dynasty 18.

DRAWING CONVENTIONS

When confronting an Egyptian two-dimensional scene, modern viewers may be troubled by the initial impression of awkwardness or lack of sophistication. For better or worse, generations of schoolchildren have been taught that the "best" art reproduces nature, that drawing conventions such as foreshortening and perspective indicate an advanced level of artistic expression. Why didn't Egyptian artists at least try to show objects as we see them? Weren't they advanced? Or were they trying to do something completely different?[35]

A typical Old Kingdom relief (Fig. 74) may help us understand the artist's intentions. The subject is a major official named Kagemni; he stands, fac-

ing right, with a staff in one hand and a scepter of authority in the other. The alert viewer will notice that his eye is drawn frontally, his nose in pure profile, and his chest *en face* (except for the left breast, which is visible just under the armpit). The arches of both feet are clearly visible, and he seems to have two left feet. This relief epitomizes an Egyptian artist's approach to drawing. He started with an image—in this instance, a man (Kagemni)—and isolated in his mind each major component of the figure. He then decided how to represent the components so that they would be understood by the viewer. Eyes are best appreciated by staring directly into a face; in profile, there is no sense of their shape, color, or other features. Noses, however, with their limitless variations of profile, are at their most distinct from the

81

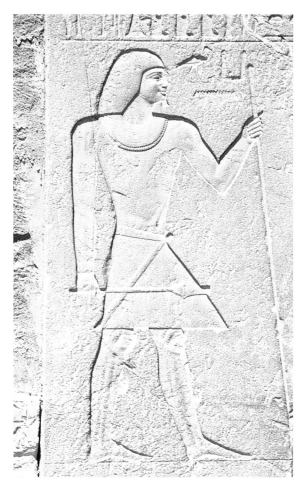

(Fig. 74) Relief from the tomb of Kagemni at Saqqara, Dynasty 6.

side. This process of mentally isolating elements and defining each one's most distinct image continued for all parts of the body; the discrete elements were then reassembled to create a coherent whole, a picture of this nobleman. The artist made no effort to show Kagemni as he appeared; the intent was far more didactic. He wanted the viewer to *understand* the whole by comprehending the parts. This is the way Egyptian artists drew, from their first experiments with artistic expression (Fig. 29) to the last expressions of their craft (Fig. 75). Their drawings strove for cerebral, not visual, goals.

Rather than indicating a primitive level of accomplishment, the technique of breaking down parts of a whole and then reassembling them goes to the essence of human creativity. Any parent or teacher who has watched a child draw a house as

a triangle on top of a square has observed this process firsthand. Not only children, but most pre-Greek or non-Greek peoples—including the Sumerians of ancient Mesopotamia, the Minoans of Crete, the indigenous Australians, and the Yoruba people of Benin and Nigeria—drew as they thought and not as they saw. Only when we enter school and learn that the Greeks knew the "right" way to draw do we first experience self-consciousness about renderings that are not "natural." Self-expression becomes encumbered by an unfortunate cultural relativism: Greek/European art = good, and Egyptian/African art = inferior. All the more regrettable because, on the most basic human level, we all draw like Egyptians.

The communicative purpose of Egyptian art offers an answer to one of the most common questions asked about ancient sculpture: Why do standing statues always have the left leg forward (Fig. 76)? The Egyptians wrote in a variety of scripts, but the most familiar was composed of hieroglyphs, or small pictures. Some hieroglyphs were purely phonetic; they stood for individual letters or combinations of two or more letters. Others were ideographic. Egyptologists call these ideographic signs "determinatives" because when more than one word is written with the same combination of phonetic glyphs, the ideographs determine for the reader which word is meant. If we look once again at the relief of Kagemni, we notice three hieroglyphs in front of his face; they represent the three elements of his name (ka + gem + ni). Yet a determinative, the small figure of a seated man, which would indicate that the glyphs refer to a male, is missing. There *is* another determinative, however: the large standing relief of Kagemni functions as the determinative for the hieroglyphic inscription.

As difficult as it may be to accept, statues also function as determinatives, providing the last element in the subject's name. The inscription on the block statue of Djed-Khonsu-iuf-ankh (Fig. 47), for example, identifies him, but the carver did not end with a determinative, the ideographic glyph of a seated man. It was not necessary to do so

(Fig. 75) *Trial piece or ex-voto with lion.* Provenance not known. Early Ptolemaic Period, 4th century B.C. Limestone. 12.1 x 16.5 x 3 cm (4¾ x 6½ x 1³⁄₁₆ in.). Collection of The Walters Art Museum, Baltimore. 22.43.

because the block statue itself is the determinative. The Egyptians' writing system permitted them to write from left to right or from right to left, although the latter was preferred. It is possible to recognize the orientation of a text by finding a human or animal sign, which always looks toward the beginning of the inscription. Hieroglyphs written from right to left face right, as in the relief of Kagemni. In images with this orientation, if the right leg is advanced, part of the left would be obscured; if both legs are held together, only one would be seen. The only acceptable alternative for a right-facing determinative is to extend the left leg outward. Striding statues—in reality, three-dimensional hieroglyphs—adopted this same pose.

MAGIC, RELIGION, AND THE PERSONAL ARTS

We live in a culture that institutionalizes a distinct separation between the sacred and the profane. It is very difficult for any member of a society such as ours to understand how religion can so profoundly affect the social, political, and artistic components of another society. The reader could not be faulted for wondering if this essay has placed too great an emphasis on the pervasiveness of religion in ancient Egypt and particularly in its art. Yet, as we insist on rigidly maintaining our culture's need to divide and categorize, focusing on differences rather than connections, we will never approach an understanding of the Egyptians. Their worldview stressed unity, similarity, and commonality. All the statues and reliefs exhibited here served inherently religious

(Fig. 76) Entrance to the temple of Ramesses III in the temple of Amun at Karnak, Dynasty 20.

functions while being visually arresting and communicative.

Maybe I've forced the issue. The objects that are part of *In the Fullness of Time* came from tombs and temples, so their religious associations should hardly surprise us. Yet even when we look at utilitarian items, the so-called personal arts, we recognize that religious themes and imagery determined their designs. Mirrors of the Middle Kingdom, Second Intermediate Period, and early Eighteenth Dynasty, for example, were held by handles cast in the form of papyrus plants supporting highly polished disks that are *always* elliptical (Fig. 77). This signal feature is a crucial clue to understanding the symbolism embedded in the design. The elliptical shape reproduces the sun's outline as it emerges over the eastern horizon at dawn. The total composition, then, symbolizes the sun's emergence, at the First Moment, from the primordial papyrus swamp (Nun). An Egyptian could not pick up a mirror without being reminded of the solemn obligation to maintain *ma'at* and help re-create Creation daily.

What we call "superstition" is often just the other fellow's religion, expressed in a personal manner. The intent is religious, just not cultic. On a mundane level, Egyptian jewelry allowed a conspicuous display of personal expression, but it served apotropoaic functions as well, providing magical protection from malevolent spirits, from bad fortune, and, particularly, from death.[36] Jewelers chose specific materials to enhance an object's power. Gold's resistance to tarnishing made it seem immortal; to the Egyptians, it was the indestructible "flesh of the gods." Red semiprecious stones like carnelian alluded to blood's life-giving properties, and green stones such as turquoise and amazonite referred to vegetation, fertility, and thus resurrection. Lapis lazuli's deep blue color and characteristic gold flecks suggested the night sky and the "undying" stars that never dipped below the horizon.

Magical power could also derive from an object's design. Many necklaces and bracelets feature amulets, specialized beads or charms that promised good fortune and protection against evil.[37] Egyptian amulets usually depict familiar forms

84

(Fig. 77) *Mirror* (left). Abydos, tomb E145. Late Middle Kingdom–Second Intermediate Period, c. 1759–1539 B.C. Bronze. 19.1 x 10.2 x 2.54 cm (7½ x 4 x 1 in.). Collection of the University of Pennsylvania Museum of Archaeology and Anthropology, Philadelphia. Egyptian Research Account, 1900. E.9211.

such as body parts, animals, gods, or ritual objects. Some might bear the name of an important ruler whose efficacy in defense of the Egyptian people might, it was hoped, be transferred to the amulet's owner (Fig. 36). Others conveyed ideas that take the form of three-dimensional hieroglyphs. The *nefer*-sign, the hieroglyph for "good[ness]" and "beauty," frequently appeared on necklaces worn to secure these properties for the owner (Fig. 37).

Religious imagery even followed Egyptians to bed. The ancient equivalent of our pillow was a headrest consisting of a curved support mounted on a pillar (Fig. 41). The headrest cradled the head while supporting the neck of the sleeper, who was obliged to lie on his or her side.[38] When a head rested on the device, the combination of round and curved forms resembled the Egyptian hieroglyph for "horizon," the morning sun emerging over the twin peaks of the horizon. Thus, the sleeping Egyptian was identified with the newly born sun, a potent symbol of resurrection, and, ideally, would be reborn, like the sun at dawn.

One final class of personal arts must be mentioned, although, because its function was so explicitly spiritual, it cannot strengthen the

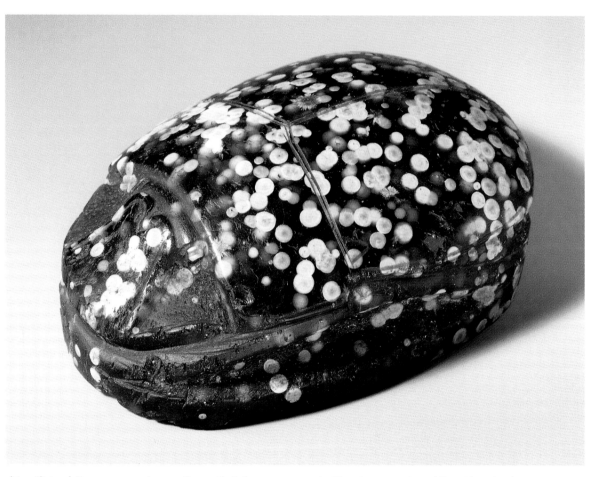

(Fig. 78) *Scarab*. Provenance not known. Roman Period, 30 B.C.–A.D. 363. Glass. 8.9 x 6 x 3.8 cm (3½ x 2⅜ x 1½ in.). Collection of The Metropolitan Museum of Art. Bequest of W. Gedney Beatty, 1941. 41.160.132.

argument that craftsmen imposed religious imagery on utilitarian objects. No doubt the type of Egyptian amulet most commonly brought back from modern Egypt by tourists wishing to own just one souvenir is the scarab (Fig. 78). Scarabs are charms reproducing the shape of the common Egyptian dung beetle (*Scarabaeus sacer*). The beetle rolls cattle dung, collected from the desert floor, into a ball. It then pushes the ball into a hole and eats it. When the Egyptians saw the scarab's young emerging from the hole, they mistakenly believed that the newly born insects were created in the mass of cattle dung the beetle had collected. This misunderstanding led to the belief that the scarab beetle could create new life, and it came to symbolize rebirth and regeneration from the sterile death represented by the dung ball.

Scarabs began to appear in Dynasties 9 and 10 (c. 2130–1980 B.C.) of the First Intermediate Period.

The earliest scarabs were worn as amulets on rings, bracelets, and necklaces. Their undersides normally feature decorative patterns sometimes enhanced by magical hieroglyphs wishing the wearer life, protection, or goodness. Others bear the name of a king or the scarab's owner. Scarabs eventually functioned as seals. Hieroglyphic texts with the owner's name and, frequently, title were carved onto the scarab's flat bottom and pressed into damp clay to seal a jar or box. Here, again, we see the merging of the sacred and the commonplace. What began as an image of resurrection, like a crucifix, evolved into the equivalent of a modern signet ring. Sorry to say that nearly every scarab brought back from Egypt today is a modern forgery that reproduces the ancient amuletic form but is rarely more than a few months old. *Caveat emptor!*

CONCLUSION

Early in this essay, we set out to examine why Egyptian art cannot be confused with the art of any other culture. Part of the answer is that Egyptian artists were responding to religious motivations unlike any others. The form and iconography of statues and the symbolic nature of two-dimensional representations were part of the Egyptians' unique system of belief and ceremony. This system rested on an acceptance of cyclical repetition and the need for good to maintain a balance with chaos and evil. Even more to the point, the peculiarities of Egyptian art jibe with the ability of human beings to see, analyze, and remember.

Art historians study three aspects of artistic expression: form, iconography, and style. Each of these had a different dynamic in ancient Egypt. Form changed little over time and then nearly always in response to a modification in the religious sphere. Iconography, too, tended to remain static, principally because it functioned as a means of conveying information that had to be conventional and readily understandable. Style was the most protean, reacting to many factors outside the realm of religion. Of these three, humans respond earliest to form.[39] An eighteen-month-old child can easily distinguish Cookie Monster from Oscar the Grouch because of the differences in their basic appearance—form. Iconography comes into play later. Only when the child masters the raw distinctions between, say, Bert and Ernie, does the exclusive connection between Ernie and his rubber ducky assume significance. The ability to make stylistic distinctions comes much later, if it comes at all. A five-year old might be able to tell that a teenager in a purple dinosaur suit entertaining at a birthday party isn't the real thing because he "doesn't act like Barney." Press the youngster for a more detailed analysis, however, and you'll probably hear something like, "I don't know, he just doesn't."

Egyptian art has a highly restricted number of forms, so people can internalize them with relative ease, much as our eighteen-month-old child is able to identify the characters on *Sesame Street* after watching only a dozen episodes or so. Similarly, the iconographic cues in Egyptian art are so limited in number that modern viewers can easily come to recognize them even if complete understanding must await a graduate degree in Egyptology. The one factor that commands intense scrutiny, changes in style, is of the least concern to the human mind because it does the least to aid understanding. Egyptian art's elemental appeal is enhanced by ancient drawing conventions that rely on the isolation of parts and the reassemblage of these separate components into a comprehensible whole, an approach we have seen to be consistent with childhood drawing. The Egyptians presented their two-dimensional art using techniques identical to those employed by the young; simultaneously, they devised art forms and iconography that appeal to our earliest stages of cognition. Egyptian art is recognizable because it utilizes the basic human approach to understanding and expression while elevating that approach to an aesthetic level of undeniable excellence.

James F. Romano is Curator of Egyptian, Classical, and Ancient Middle Eastern Art at the Brooklyn Museum of Art, New York.

1. Quoted in Francis Steegmuller, ed. and trans., *Flaubert in Egypt: A Sensibility on Tour; A Narrative Drawn from Gustave Flaubert's Travel Notes & Letters* (Boston: Little, Brown, and Company, 1972), 57.

2. Quoted in William S. McFeely, *Frederick Douglass* (New York: Simon & Schuster, 1991), 329.

3. A number of excellent English-language surveys of ancient Egyptian art have appeared in the last twenty-five years. Among the most helpful and comprehensive are Cyril Aldred, *Egyptian Art in the Days of the Pharaohs, 3100–32 B.C.* (New York: Oxford University Press, 1980); Jaromir Malek, *Egyptian Art* (London: Phaidon Press, 1999); Gay Robins, *The Art of Ancient Egypt* (Cambridge: Harvard University Press, 1997); William Stevenson Smith, *The Art and Architecture of Ancient Egypt*, rev. ed. with additions by William Kelly Simpson (New Haven, Conn.: Yale University Press, 1998); and Richard H. Wilkinson, *Reading Egyptian Art: A Hieroglyphic Guide to Ancient Egyptian Painting and Sculpture* (London: Thames and Hudson, 1992).

4. Serge Sauneron, *The Priests of Ancient Egypt*, trans. Ann Morrissett (New York: Grove Press, 1960), 6–7.

5. For ancient Egyptian architecture, see especially Dieter Arnold, *Building in Egypt: Pharaonic Stone Masonry* (New York: Oxford University Press, 1991); Alexander Badawy, *Ancient Egyptian Architectural Design: A Study in Architectural Design* (Berkeley and Los Angeles: University of California Press, 1965); Alexander Badawy, *A History of Egyptian Architecture II: The First Intermediate Period, the Middle Kingdom, and the Second Intermediate Period* (Berkeley and Los Angeles: University of California Press, 1966); Alexander Badawy, *A History of Egyptian Architecture III: The Empire (the New Kingdom) from the Eighteenth Dynasty to the End of the Twentieth Dynasty, 1580–1085 B.C.* (Berkeley and Los Angeles: University of California Press, 1968); Alexander Badawy, *A History of Egyptian Architecture I: From the Earliest Times to the End of the Old Kingdom* (London: Histories & Mysteries of Man, 1990); Jean-Louis de Cenival, *Living Architecture: Egyptian*, preface by Marcel Breuer (New York: Grosset & Dunlap, 1964); I. E. S. Edwards, *The Pyramids of Egypt* (New York: Viking Penguin, 1986); Ahmed Fakhry, *The Pyramids* (Chicago: University of Chicago Press, 1961); Zahi A. Hawass, *The Pyramids of Ancient Egypt* (Pittsburgh: Carnegie Museum of Natural History, 1990); Mark Lehner, *The Complete Pyramids: Solving the Ancient Mysteries* (London: Thames and Hudson, 1997); E. Baldwin Smith, *Egyptian Architecture as Cultural Expression* (New York: D. Appleton-Century Company, 1938); and Steven Snape, *Egyptian Temples*, Shire Egyptology, no. 24 (Princes Risborough, England: Shire Publications, 1996).

6. For an excellent introduction to this complex topic, see Gay Robins, *Egyptian Statues*, Shire Egyptology, no. 26 (Princes Risborough, England: Shire Publications, 2001). Other important references include T. G .H. James and W. V. Davies, *Egyptian Sculpture* (London: British Museum Publications, 1983); Edna R. Russmann, *Egyptian Sculpture: Cairo and Luxor* (Austin: University of Texas Press, 1989); and Robert Steven Bianchi, "Ancient Egyptian Reliefs, Statuary, and Monumental Paintings," in *Civilizations of the Ancient Near East*, vol. IV, ed. Jack M. Sasson (New York: Charles Scribner's Sons, 1995), 2533–54. For artists and craftsmen, see Rosemarie Drenkhahn, "Artisans and Artists in Pharaonic Egypt," in *Civilizations of the Ancient Near East*, vol. I, ed. Jack M. Sasson (New York: Charles Scribner's Sons, 1995), 331–43.

7. The definitive sources for Egyptian stones are A. Lucas, *Ancient Egyptian Materials and Industries*, 4th ed., rev. J. J. R. Harris (London: Histories & Mysteries of Man, 1989), 50–74, and Barbara G. Aston, *Ancient Egyptian Stone Vessels and Forms*, Studien zur Archäologie und Geschichte altägyptens 5 (Heidelberg, Germany: Heidelberger Orientverlag, 1994), 11–73.

8. For early wooden sculpture, see Julia Harvey, *Wooden Statues in the Old Kingdom: A Typological Study*, Egyptological Memoirs 2 (Leiden, Netherlands: Brill·Styx, 2001). For a summary of woodworking techniques, consult Geoffrey Killen, *Egyptian Woodworking and Furniture*, Shire Egyptology, no. 21 (Princes Risborough, England: Shire Publications, 1994).

9. A general discussion of Egyptian casting techniques appears in Bernd Scheel, *Egyptian Metalworking and Tools*, Shire Egyptology, no. 13 (Princes Risborough, England: Shire Publications, 1989), 40–43; for a more detailed treatment, see Lucas, *Ancient Egyptian Materials and Industries*, 199–223.

10. For a good introduction, see Gay Robins, *Egyptian Painting and Relief*, Shire Egyptology, no. 3 (Princes Risborough, England: Shire Publications, 1986). Consult also William Stevenson Smith, *History of Egyptian Sculpture and Painting in the Old Kingdom*, (1946; reprint, New York: Hacker Art Books, 1978), 244–57, and Bianchi, "Ancient Egyptian Reliefs, Statuary, and Monumental Paintings," 2533–54.

11. Richard A. Fazzini, "Some Egyptian Reliefs in Brooklyn," *Miscellanea Wilbouriana* I (1972): 48–49.

12. This paragraph draws heavily from the work of Gay Robins, *Proportion and Style in Ancient Egyptian Art* (Austin: University of Texas Press, 1994). Professor Robins's book must now supersede the arguments expressed in Erik Iversen with Yoshiaki Shibata, *Canon and Proportions in Egyptian Art*, rev. ed. (Warminster, England: Aris and Phillips, 1975).

13. T. G. H. James, *Egyptian Paintings in the British Museum* (London: British Museum Publications, 1985); Arpag Mekhitarian, *Egyptian Painting, The Great Centuries of Painting* (Geneva: Editions d'art Albert Skira, 1954); Robins, *Egyptian Painting and Relief*; Smith, *History*, 263–72; Edward L. B. Terrace, *Egyptian Painting of the Middle Kingdom: The Tomb of Djehuty-nekht* (New York: George Braziller, 1968); Charles K. Wilkinson and Marsha Hill, *Egyptian Wall Paintings: The Metropolitan Museum of Art's Collection of Facsimiles* (New York: Metropolitan Museum of Art, 1983).

14. Hannelore Kischkewitz, *Egyptian Drawings* (London: Octopus Books, 1972); William H. Peck, *Egyptian Drawings*, photos John G. Ross (New York: E. P. Dutton, 1978).

15. James F. Romano, "Jewelry and Personal Arts in Ancient Egypt," in *Civilizations of the Ancient Near East*, vol. III, ed. Jack M. Sasson (New York: Charles Scribner's Sons, 1995), 1605; the most comprehensive treatment of Egyptian personal arts, focusing on New Kingdom pieces, is Edward Brovarski, Susan K. Doll, and Rita E. Freed, eds., *Egypt's Golden Age: The Art of Living in the New Kingdom 1558–1085 B.C.* (Boston: Museum of Fine Arts, 1982).

16. Cyril Aldred, *Jewels of the Pharaohs: Egyptian Jewelry of the Dynastic Period* (New York: Praeger Publishers, 1971); Carol Andrews, *Ancient Egyptian Jewelry* (New York: Harry N. Abrams, 1991); Brovarski et al., *Egypt's Golden Age*, 227–54; Romano, "Jewelry and Personal Arts," 1605–13; Scheel, *Egyptian Metalworking*, 44–46; Alix Wilkinson, *Ancient Egyptian Jewellery* (London: Methuen & Co., 1971).

17. Florence Dunn Friedman, "Faience: The Brilliance of Eternity," in Florence Dunn Friedman, ed., *Gifts of the Nile: Ancient Egyptian Faience* (New York: Thames and Hudson, 1998), 15–21; Robert Steven Bianchi, "Symbols and Meanings," in Friedman, ed., *Gifts of the Nile*, 22–32; Diana Craig Patch, "By Necessity of Design: Faience Use in Ancient Egypt," in Friedman, ed., *Gifts of the Nile*, 32–45.

18. Karl W. Butzer, *Early Hydraulic Civilization in Egypt, Prehistoric Archaeology and Ecology* (Chicago: University of Chicago Press, 1976); Hermann Kees, *Ancient Egypt: A Cultural Topography*, ed. T. G. H. James, trans. Ian F. D. Morrow (Chicago: University of Chicago Press, 1976), especially 17–44.

19. In fact, Herodotus never called Egypt "the gift of the Nile." The precise quote is "For it would be clear to anyone of sense who used his eyes, even if there were no such information, that the Egypt to which the Greeks sail is land that has been given to the Egyptians as an addition and as a gift of the river." For further information, see Herodotus, *The History* 2.5.

20. This great natural process ended in the early 1960s with the completion of the Aswan Dam.

21. James P. Allen, *Genesis in Egypt: The Philosophy of Ancient Egyptian Creation Accounts*, Yale Egyptological Studies 2 (New Haven, Conn.: Yale Egyptological Seminar, 1988); George Hart, *Egyptian Myths, The Legendary Past* (Austin: University of Texas Press, 1990), 9–17; Leonard H. Lesko, "Ancient Egyptian Cosmogonies and Cosmology," in Byron E. Schafer, ed., *Religion in Ancient Egypt: Gods, Myths, and Personal Practices* (Ithaca, N.Y.: Cornell University Press, 1991), 88–115.

22. J. Gwyn Griffiths, *The Conflict of Horus and Seth: A Study in Ancient Mythology from Egyptian and Classical Sources* (Liverpool, England: Liverpool University Press, 1960); Hart, *Egyptian Myths*, 29–41.

23. Not long after the 1994 release of Walt Disney Pictures' *The Lion King*, some controversy arose about the originality of the story. One source, for example, claimed that the screenwriters appropriated the narrative from a Japanese folktale. As an Egyptologist watching from afar, I found the debate quite amusing. Whether knowingly or not, the writers had tapped into the earliest *Egyptian* myth, the story of Osiris, Seth, and Horus. In both, a wise king (Osiris/Mufasa) is slain by his wicked brother (Seth/Scar), who seizes the throne with the aid of malevolent agents (hippos/hyenas). The dead king's son (Horus/Simba) hides from his vengeful uncle (in a swamp/in the jungle) until he is old enough to confront the usurper and take the throne with the aid of a wise baboon (Thoth/Rafiki).

24. See Leonard H. Lesko, "Ancient Myths," in Byron E. Schafer, ed., *Religion in Ancient Egypt: Gods, Myths, and Personal Practices* (Ithaca, N.Y.: Cornell University Press, 1991), 91.

25. See especially John Baines, "On the Status and Purposes of Ancient Egyptian Art," *Cambridge Archaeological Journal* 4 (1994): 67–94.

26. For information on matters such as tomb design, mummification, and provisioning a tomb, see A. J. Spencer, *Death in Ancient Egypt* (New York: Penguin Books, 1982).

27. Marsha Hill, "Note on the Dating of Certain Stone Serving Statuettes," in *Egyptian Art in the Age of the Pyramids* (New York: Metropolitan Museum of Art, 1999).

28. The most famous instance of a broken nose is probably also the most misunderstood. Napoleon is often blamed for destroying the nose of the Great Sphinx at Giza when he invaded Egypt in 1799. According to tradition, his artillerymen practiced their skills by shooting at the Sphinx's face with a cannon; supposedly, one well-placed shot smashed the nose. Much evidence can be presented to challenge this theory. For example, numerous renderings of the Great Sphinx made long before 1799 show it with the nose already gone. And according to several Medieval Arab authors, the Giza Sphinx was defaced in 1378 by a

fanatical Sufi named Mohammed Sa'im al-Dahr, who felt that this legendary statue was sacrilegious.

29. The reader interested in pursuing the question of Egyptian style could do no better than to consult the writings of Edna R. Russmann, including her *Egyptian Sculpture: Cairo and Luxor* and Edna R. Russmann et al., *Eternal Egypt: Masterworks of Ancient Art from the British Museum* (Berkeley and Los Angeles: University of California Press, 2001).

30. Peter Der Manuelian, *Living in the Past: Studies in Archaism of the Egyptian Twenty-sixth Dynasty* (New York: Kegan Paul International, 1994), and Russmann, "Archaism," in *Eternal Egypt*, 40–45.

31. Russmann, "Portraiture," in *Eternal Egypt*, 32–39 (with earlier references).

32. See, for example, Clifford J. Geertz, "Religion as a Cultural System," in Michael Banton, ed., *Anthropological Approaches to the Study of Religion* (New York: Frederick A. Praeger, 1966), 4–28.

33. Gay Robins, "Problems in Interpreting Egyptian Art," *Discussions in Egyptology* 17 (1990): 45–58.

34. Torgny Save-Söderbergh, "On Egyptian Representations of Hippopotamus Hunting as a Religious Motive," *Horae Soederblomianae: Travaux publié par la Société Nathan Söderblom* 3 (1953): 1–56.

35. Heinrich Schäfer, *Principles of Egyptian Art*, ed. Emma Brunner-Traut, ed. and trans. by John Baines (Oxford, England: Clarendon Press, 1974); Smith, *History*, 273–332.

36. For Egyptian magic, see Geraldine Pinch, *Magic in Ancient Egypt* (Austin: University of Texas Press, 1994), and Robert Kriech Ritner, *The Mechanics of Ancient Egyptian Magical Practice*, Studies in Ancient Oriental Civilization 54 (Chicago: University of Chicago Press, 1993).

37. For amulets, consult Carol Andrews, *Amulets of Ancient Egypt* (London: British Museum Press, 1994), and Pinch, *Magic*, 104–19.

38. This shape survives in contemporary Africa; see Rebecca L. Green, "African Headrests," in Theodore Celenko, ed., *Egypt in Africa* (Indianapolis: Indianapolis Museum of Art and Indiana University Press, 1996), 46–49.

39. I do not pretend to be a scholar of developmental psychology, but I have watched two children learn to recognize the world around them, especially the world of television.

CHRONOLOGY

PREDYNASTIC PERIOD: BADARIAN AND NAQADA PERIODS, DYNASTY O

c. 4400–3000 B.C.

Badarian Period	c. 4400–3800 B.C.
Naqada I Period	c. 3850–3650 B.C.
Naqada II Period	c. 3650–3300 B.C.
Naqada III Period	c. 3300–3100 B.C.
Dynasty 0	c. 3100–3000 B.C.

EARLY DYNASTIC PERIOD: DYNASTIES 1 AND 2

c. 3000–2675 B.C.

Dynasty 1	c. 3000–2800 B.C.
Dynasty 2	c. 2800–2675 B.C.

OLD KINGDOM: DYNASTIES 3 THROUGH 6

c. 2675–2170 B.C.

Dynasty 3	c. 2675–2625 B.C.
Dynasty 4	c. 2625–2500 B.C.
Dynasty 5	c. 2500–2350 B.C.
Dynasty 6	c. 2350–2170 B.C.

FIRST INTERMEDIATE PERIOD: DYNASTY 7 THROUGH
FIRST HALF OF DYNASTY 11

c. 2170–2008 B.C.

Dynasties 7 and 8	c. 2170–2130 B.C.
Dynasties 9 and 10	c. 2130–1980 B.C.
First half of Dynasty 11	c. 2081–2008 B.C.

MIDDLE KINGDOM: LATTER HALF OF DYNASTY 11 THROUGH
FIRST PART OF DYNASTY 13

c. 2008–1721 B.C.

Latter half of Dynasty 11	c. 2008–1938 B.C.
Dynasty 12	c. 1938–1759 B.C.
First part of Dynasty 13	c. 1759–1721 B.C.

SECOND INTERMEDIATE PERIOD: SECOND PART OF DYNASTY 13
THROUGH DYNASTY 17

c. 1721–1539 B.C.

Second part of Dynasty 13	c. 1721–after 1630 B.C.
Dynasty 14	dates uncertain
Dynasty 15	c. 1630–1539 B.C.
Dynasty 16	c. 1630–1539 B.C.
Dynasty 17	c. 1630–1539 B.C.

NEW KINGDOM: DYNASTIES 18 THROUGH 20

c. 1539–1075 B.C.

Dynasty 18	c. 1539–1292 B.C.
Dynasty 19	c. 1292–1190 B.C.
Dynasty 20	c. 1190–1075 B.C.

THIRD INTERMEDIATE PERIOD: DYNASTIES 21 THROUGH 25

c. 1075–656 B.C.

Dynasty 21	c. 1075–945 B.C.
Dynasty 22	c. 945–712 B.C.
Dynasty 23	c. 838–712 B.C.
Dynasty 24	c. 727–712 B.C.
Dynasty 25	c. 760–656 B.C.

LATE PERIOD: DYNASTIES 26 THROUGH 31

664–332 B.C.

Dynasty 26	664–525 B.C.
Dynasty 27	525–404 B.C.
Dynasty 28	404–399 B.C.
Dynasty 29	399–381 B.C.
Dynasty 30	381–343 B.C.
Dynasty 31	343–332 B.C.

MACEDONIAN PERIOD

332–305 B.C.

PTOLEMAIC PERIOD

305–30 B.C.

ROMAN PERIOD

30 B.C. – A.D. 363

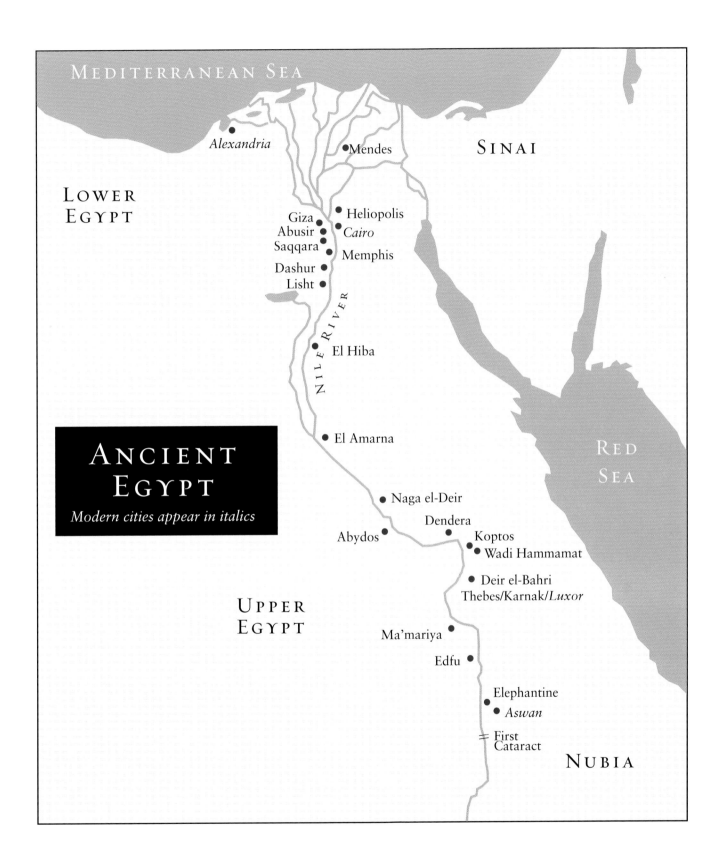

MEDITERRANEAN SEA

SINAI

LOWER
EGYPT

Alexandria

Mendes

Giza
Abusir
Saqqara
Dashur
Lisht

Heliopolis
Cairo
Memphis

NILE RIVER

El Hiba

El Amarna

ANCIENT
EGYPT

Modern cities appear in italics

Naga el-Deir

Dendera
Abydos
Koptos
Wadi Hammamat

Deir el-Bahri
Thebes/Karnak/Luxor

UPPER
EGYPT

Ma'mariya

Edfu

Elephantine
Aswan

First
Cataract

RED
SEA

NUBIA